27

New Design in CERAMICS

New Design in

CERAMICS

Donald J. Willcox

VNR VAN NOSTRAND REINHOLD COMPANY
NEW YORK CINCINNATI TORONTO LONDON MELBOURNE

For
JEAN KOEFOED
who made it all possible

OTHER BOOKS IN THIS SERIES:

NEW DESIGN IN JEWELRY
NEW DESIGN IN STITCHERY
NEW DESIGN IN WEAVING
NEW DESIGN IN WOOD

Van Nostrand Reinhold Company Regional Offices:
New York Cincinnati Chicago Millbrae Dallas

Van Nostrand Reinhold Company International Offices:
London Toronto Melbourne

Copyright © 1970 by Litton Educational Publishing, Inc.
Library of Congress Catalog Card Number 77-126867
ISBN 0-442-29463-8

Designed by Myron Hall III
Printed by Halliday Lithograph Corporation
Color printed by Toppan Printing Company, Limited, Japan
Bound by Haddon Bindery

Published by Van Nostrand Reinhold Company
450 West 33rd Street, New York, N.Y. 10001

Published simultaneously in Canada by
Van Nostrand Reinhold Ltd.

16 15 14 13 12 11 10 9 8 7 6 5 4 3 2

CONTENTS

The word "change" has become almost the keynote of the twentieth century. We live in era of change, we are told, and like it or not, it has affected every level of our endeavor. The crafts are no exception. You need only look around at the current work of the craftsman, especially the potter, to discover firsthand evidence of dramatic change.

Often-heard phrases like "modern crafts movement" and "modern crafts revival" exemplify the type of vigorous activity that has taken place in the crafts during the past decade. The craftsman has been bursting with curiosity and creative energy. Rules have been cast aside, and clichés and stereotypes relinquished in favor of exploring the unexplored. All this has been like a cooling fog on a windless day, or more exactly, like pumping fresh blood into tired veins. The atmosphere within the crafts is now entirely optimistic. And the individual craftsman feels very much like his battery has been recharged.

The professional potter has accepted change with open arms. He has met the challenge to explore new forms, to accept new materials and techniques, and to re-examine the concepts behind his utilitarian ware. As for the student potter, change has produced in him an obsession for sculpture—almost to the point where he will now groan at the thought of making a functional form.

Change is reflected also in books published about the crafts. Twenty years ago you were lucky to find two books on the subject of a given craft, but today there are dozens on every one. Moreover, hobby books and the encyclopedic variety of crafts book that skims lightly over an entire field are going out of style—and authors are tending to specialize in a single aspect of a craft. In pottery, for ex-

ample, there are books being written just on texturing, or on glazes, or on building form without a wheel.

Obviously, the modern author of a book on crafts must have a thorough knowledge of his subject. But beyond that he has a responsibility to stimulate enthusiasm in his reader. A book dashed off on acceptable or "safe" imagery, on prize-winning forms, or on the work of only well-known potters just won't satisfy today's sophisticated—yes, even hungry—audiences. They demand information on what is newest and most exciting in contemporary crafts.

To develop a truly stimulating book on a craft is a touchy business. An author, like any other mortal, is subject to errors of taste. And of course he realizes that it is impossible to please everyone at once— what one reader likes may bore the next. But these are small matters compared with the task of finding and appreciating the uncommon in a craft—works that are truly unique. An author must look at hundreds of commonplace forms in his search for the rare exception. And that is enough to dull even the sharpest eye.

This is a book that strives after the *uncommon* in ceramics. There are no instructions on techniques of potting or how to use tools here—it was never my intention to write a how-to-do-it manual. What you will find is a visual gallery of contemporary work in Scandinavian pottery—forms that, I think, expose the potentials of the craft and point out the direction in which it is heading.

Scandinavian ceramics are not so widely appreciated outside of Scandinavia as are their other handicrafts, so I am particularly pleased to be able to present the work of these talented young potters to a non-Scandinavian audience. All of the craftsmen featured here are very much alive to the uncommon in ceramic form—

so much so, in fact, that for every work illustrated on these pages it was necessary to eliminate a dozen others of equal quality!

Nevertheless, this should not be considered a book about Scandinavian ceramics—because, strictly speaking, there are no national forms in this medium. It pays tribute to Scandinavian artistry, that is true, but the outlook is international—and it is offered to potters in the spirit of sharing.

THE POTTER'S PLACE IN SCANDINAVIAN SOCIETY

Many potters look upon Scandinavia as a virtual paradise for the craftsman. Although there is still room for improvement, it is safe to say that the working environment in Scandinavia is perhaps unmatched anywhere else in the Western world for promoting creativity. To understand more fully the atmosphere in which the Scandinavian potter works, we should take a look at some of the myths and realities that surround him.

There are two types of potter in Scandinavia: the potter who works in industry, and the potter who is self-employed. The ceramics industry in Scandinavia is large and powerful, dominating the marketplace and in many instances consuming most of the available talent. This is particularly the case in Finland, where the lone potter must shout, so to speak, to make his voice heard in the commercial throng.

The largest and one of the best-known ceramics firms in Scandinavia is Arabia of Finland, which alone produces over eight thousand objects. Arabia has a staff of more than seventeen hundred in one factory and a tunnel kiln so large that it can hold sixty carloads of stacked pots in one firing. Other giant manufacturers include A. B. Rorstrand and A. B. Gustavsberg, both of Sweden, and Bing & Grondahl and Royal Copenhagen of Denmark. One of the leading small manufacturers of ceramics in Scandinavia is A. B. Hognas of Sweden.

Within industry, potters are once again divided into two groups: one group comprises the salaried potters who design commercial ware—that is, tableware, statuary, and sanitary ware; the other group, the so-called free artists. A free artist's main function is to design ceramic ware that will promote the firm's *artistic* image, and thus he occupies a somewhat higher position in the industrial hierarchy. Ceramic forms created by him are regularly entered in regional and international competitions. Naturally, when he is awarded

a prize, the honor is widely publicized by the firm that sponsored him.

Basically, the working environment in industry is such that the potter is encouraged to feel creatively independent. The situation of the free artist is particularly good, for he is being paid to experiment in his craft. Moreover, he has at his disposal an unlimited supply of equipment and raw materials, and the expert advice of highly skilled ceramic technicians.

This marriage of creativity and commercialism usually works to the betterment of both parties: the potter eats regularly, and the company makes a profit. However, there is always the danger in industry of departmentalizing—and thus stifling—the creative artist. Then, too, a guaranteed income tends to weaken some individuals and make them more complacent about their work. Kaj Franck, the art director at Arabia, tells me that this is a constant problem, and he is always reminding his potters that their personal integrity is far more valuable to them than is a public image and even a high salary. But problems notwithstanding, the marriage matures with each new season. One young potter at Arabia confided to me that despite any complaints he might have, he considered himself fortunate to be there. He knew that twenty like him were outside the door and trying to get in.

As you have probably guessed, the potter who selects to be on his own is the rugged individualist. Some of these potters have never been tempted by commercial opportunities, others are renegades from industry who want to try it on their own again. It is not exaggerating to say, however, that the self-employed potter must be dedicated, passionate, and infinitely strong to survive the competition. But if he does, his work is usually so strong that he can often outdistance his industrial rival in reputation and in income.

ART EDUCATION IN SCANDINAVIA

Generally speaking, all Scandinavian design schools are oriented toward training the potter for industry. Nevertheless, teaching concepts vary a great deal from one school to the next; and since the potter is very much a product of his school, it is helpful to examine the type of education he gets. In addition, it is hoped that this brief survey will provide the American educator with food for thought in re-evaluating his own educational concepts.

There are six major design schools in Scandinavia: one in Finland, two in Sweden, one in Denmark, and two in Norway. All of these schools are government-supported, and because they are small, enrollment competition is severe. (Despite their size and the number of Scandinavian students who apply, schools also occasionally accept foreign students.) Restricting enrollment is a means of controlling the number of craftsmen who will eventually ply their trade in Scandinavia, thus preventing them from becoming a glut on the market. It must be admitted in defense of this that most graduates of Scandinavian design schools are able to earn a respectable income. However, the system has been justly criticized by many people who feel that a fine arts education should be available to everyone who wants it—and not just a select minority.

THE ATENEUM IN FINLAND Since 1963, the ceramics department at the Ateneum has been run by Kyllikki Salmenhaara, a fugitive free artist from Arabia and undoubtedly one of the most forceful potters Finland has ever produced. She is the recipient of dozens of awards in ceramics, and her influence at Arabia has been so strong

that it is still apparent in Arabia forms, even though it has been many years since she was a member of the Arabia staff. In addition to talent, Miss Salmenhaara has a thorough knowledge of ceramic chemistry, kiln-building, and firing. To illustrate, while she was at Arabia she always insisted on making her own clay and her own glazes, and even testing them herself—a rare practice among potters in industry.

Miss Salmenhaara has always been thoroughly independent in her attitude toward ceramics. One of the first things she did when she took up her job at the Ateneum was to change the rather easy-going educational program then in practice in her department. She introduced her own system, which is designed to develop habits of self-discipline in the student and to prepare him for professional life. To this end, and also because the school has a low budget for supplies, she teaches her students how to use the native red clay of Finland in their work.

Her aim in making students obtain clay raw from the soil and then refine it themselves is to get them to know clay on a personal basis—as something other than a ready-made substance obtained from the local supplier. Once they have mastered the use of red clay they can always advance to other, more sophisticated clay bodies, but they always have that red clay—free and available in great abundance all over southeastern Finland—to fall back on. Incidentally, to prepare *herself* for this undertaking, Miss Salmenhaara went all the way to the United States to study pottery with Indians of Arizona and New Mexico.

Here are several of Miss Salmenhaara's goals for student potters: (1) The student must not be object-oriented. He does not come to a ceramics class to produce form, he comes there to learn about it.

His time for creativity will come later, after he has developed the discipline and technical competence he needs. In other words, the pot is the *end* of the educational process, not the *means.*

(2) A pot develops from the inside out, and the student should not be overly concerned about its exterior. If the potter knows how to control the inside of his form, the outside will develop correctly of its own accord.

(3) A potter must learn that form emanates from within. When he becomes artistically secure, he will be able to destroy his own work without qualms, knowing that he can always replace it by creating another form that is better.

(4) The potter who cannot build his own kiln and develop and test his own clay and glaze has no right to use these materials.

(5) Only after the potter has thoroughly explored raw materials should he tackle the problems of glaze, color, and surface texture.

(6) The overall purpose of the ceramics education is to expose the student to the maximum number of artistic alternatives. Once he knows and can handle all of these, then he is ready to create *controlled* form.

Miss Salmenhaara has been criticized as severe and old fashioned in her approach to education. Nevertheless, she continues to demand from her students what she has always demanded of herself: complete commitment to ceramics. Knowing her and knowing her work, one would hardly expect anything else. Quite frankly, I find her approach a welcome change in this era of Instant Art.

PROGRAMS AT OTHER SCHOOLS Functionalism, of the sort once practiced at the Bauhaus, is the basis for educational programs at several other Scandinavian schools. Briefly stated, the

idea behind functionalism is as follows: the function of an object defines its form. Before designing a drinking vessel, for example, one would first of all put conventional notions about cups out of one's mind and set about to examine various aspects of the act of drinking. What shape of vessel best fits the lips? Must it always be held in the hand? What is a convenient weight for it? Will it stand without tipping? Can it be stacked with others? Should it have a handle? If so, how many holes will be needed for the fingers? And what shape should they be?

This process is deliberate and well-organized, if a bit painful and time-consuming. Nevertheless, in functional design all utilitarian ware is put to the test—often with surprising improvements on standard forms. With the cup, for instance, testing has given us double-walled vessels that retain more heat, handles with multiple finger holes for easier holding, the cup with the drinking spout, and cups that can be stacked more easily. To date, however, no one seems to have improved on the traditional bowl-with-handle form.

A POTTER IS A POTTER This view is advanced by those potters who feel that it is a potter's task to make pots—and that's all. They explain that to make useful household objects is a noble pursuit; there is no need for the potter to become a sculptor. Of course, this is not a popular attitude with students and young potters; but in defense of traditionalists, it must be said that their functional ware is well-defined, strong, and honest of form.

Considerably more popular with the younger generation are those educators who let the students do exactly what they please artistically—generally in the name of self-education or "learning experiences." These teachers apparently operate on the theory that there

is within each of us an "instinctive" self-discipline, which will appear sooner or later under conditions of maximum freedom.

THE CERAMIC FORM: HOW IT IS MADE

Form, texture, and color are characteristics common to all ceramics. After that, however, pottery can be divided into distinct types; the purely decorative—and that includes ceramic sculpture—and the utilitarian. Within the latter category are: forms which are pre-eminently functional, such as simple and unadorned items of household use; and tableware, vases, candleholders, and ashtrays that are both functional *and* decorative. Admittedly, the foregoing division is somewhat arbitrary, but it serves to point out to the reader that *alternatives of intent* do exist in the creation of ceramic form.

The Scandinavian potter has a very practical eye. When he creates a form that is meant to be utilitarian, it is just that. When he makes a teapot, for example, you can be sure that the spout will not dribble tea on your best tablecloth, nor will the handle heat up and burn your hand. His cups are comfortable in the hand, sturdy, lightweight, and convenient to stack and store. This doesn't mean that he is unimaginative in his approach to design problems, for he is not. But from the very first, he has learned to discipline himself as a craftsman—and he is able to strike a balance between functional demands and originality in his forms.

In sculpture, of course, the potter has more freedom to experiment. Nevertheless, the sculptor, too, is guided by practical considerations. Say he has designed a tall, elegant sculpture, and his kiln is

not large enough to accommodate the height. He will probably be forced to join the pieces together after the clay is fired—and horizontal seams on such a form will surely destroy its upward flow. Whenever I see errors of that sort in a piece of sculpture, I think of a man who is smartly dressed in a tuxedo—with his shirt tails flopping out!

It would be impossible in a text of this size to discuss Scandinavian potting techniques in any detail, but I have tried through photographs to give the reader an idea of the many potentials for building form with clay and, wherever possible, to illustrate how it has been done. Basic methods for construction in ceramics are universal: sand-casting, throwing, slabbing, casting, and pinching. Potters also devise their own unique methods for building form, and they often combine two or more techniques to gain the effects they desire. For example, clay form may be built over a wire support, like the piece in Figure 140; over something collapsible, such as a plastic bag filled with sand; or over paper that can be burned out afterward. The truly original potter is always testing and refining his methods with clay, and he is always striving to improve his medium of expression.

CLAY Every kind of clay work is represented in these pages, from fine porcelain and faïence to red clay and ordinary bathroom tile. The clay substance most favored among Scandinavian potters, however, is chamotte, a blend of unfired clay and crushed particles of fired clay. One of the great advantages of a chamotte blend is its lower rate of reduction in firing. Two chamotte clays that are presently in wide use in Scandinavia are stoneware chamotte and a chamotte blend of fired red clay and unfired stoneware.

Chamotte blends with coarse particles of fired clay are excellent for developing surface texture in ceramic work. Many modern Scandinavian sculptors are also using the ancient Oriental process of raku to produce unusual textures in clay. In raku, the ceramic form is rapidly cooled after firing, often causing the surface to become deeply fissured. Still other sculptors will bruise the clay surface with rough textured objects like tree bark (see Figures 112 and 113), press it with shells, pine cones, small metal objects, or the finger and thumb, or polish it with back of a spoon (see Figures 95, 97, and 98). Still other, more familiar techniques for texturing clay are embossing, fluting, incising, graving, scraping, and marbling.

GLAZE One of the most common methods for decorating ceramics is, of course, glaze, and it is still vastly popular in Scandinavia. A wide variety of glazes are available ready-made, among them slips made from clay thinned with water and colored with metal oxide, and preparations of ground stone; but many potters still prefer to mix their own—and they guard their formulas jealously. A ceramic form may simply be dipped in glaze; or the decorative preparation may be brushed on, poured on, sprayed on, stenciled on, or applied with a bulb and quill. A crude version of the bulb and quill—made from cow's horn and porcupine quill—is still used by many Scandinavian potters to trail slip over the ceramic form. Another, more modern technique for texturing as well as toning is fiberglass gauze soaked in slip and then wrapped around the raw clay form. In firing, the slip fuses with the clay body, leaving the latticework pattern of the fiberglass clearly visible through the glaze. This technique is also used to add body to the ceramic form.

Some potters who have grown weary of the accidents that occur

with glaze have abandoned it altogether and turned to paint. Many started with commercial enamels and then went on to mix their own preparations. Recently, some of these potters have also begun to aggressively explore polymer acrylics—and with great success. These newly developed synthetics come in a broad range of colors and are durable enough to be used even on outdoor sculpture.

FIRING METHODS Earlier I mentioned experiments with red clay by Kyllikki Salmenhaara at the Ateneum. In this section, I'd like to discuss further the potentials of this abundant and easily obtained material.

Red clay is found in large amounts in the soil of countries in the Northern Hemisphere, among them the United States. Until recently, however, it has been all but ignored for "sophisticated" ceramic works, and its use has been limited to important but uninspired things like brick, tiles, chimney liners, flowerpots, and simple dishware.

The Finnish variety of red clay is porous and heavy in iron content. In its natural state, it can be black, brown, yellow, gray, or bluish gray; yellow signals the presence of lime in the clay, and shades of brown indicate a particularly high iron content. In addition to its low cost and versatility, red clay is easy to process. It can be mixed with sand when it is too plastic, or with sawdust for a lighter, more porous clay (the sawdust burns out during the firing)—as is done in brick-making.

Any type of glaze or slip will take well on the red clay surface, but all such preparations should be mixed with a fusible oxide such as lead or borax because of the low temperature at which red clay

must be fired. "Jacket" by Zolton Popovitz (see Figure 101) is an example of red clay treated with acrylic paint.

Normally, red clay is fired at low temperatures. Kyllikki Salmenhaara and Catharina Kajander, another Finnish potter, have experimented with higher temperatures and found that at temperatures above 1100 degrees C., red clay begins to reduce too much, and by 1200 degrees C. it melts altogether. At such high temperatures—which, incidentally, are used to fire stoneware—the iron in red clay begins to burn, and the surface to pit, thus warping the form. Low firing, on the other hand, especially with smoke, prevents the iron from burning and protects surface texture.

Temperatures for firing red clay range from 980 to 1000 degrees C. (and about 700 degrees C. for smoke-firing). At these temperatures, Miss Kajander gets roughly a 10 percent reduction in the size of her forms. As a rule, she fires them only once and leaves them unglazed. Samples of her work are included in Figures 93 through 98.

One of Miss Salmenhaara's specialties with red clay is a smoke-firing method that turns the clay a rich ebony black instead of the usual smoke-gray. The secret of this method is to use rosin in the kiln along with birch and birch bark. Two other techniques which she has had great success with are combining red clay with fiberglass and using it as a slip over stoneware. She has also introduced her students to a texturing technique which produces a surface known as the "touch of velvet." When the clay is leather-hard, it is polished to a soft gloss with the back of a spoon, a rock, or some other smooth implement. The pots illustrated in the picture section by Catharina Kajander have all been buffed in this manner.

A scientific work of special value to potters on the subject of red clay is *The Mineralogical Composition of Agrillaceous Sediments of*

Finland by U. Soveri. This pamphlet, as well as reports by Miss Salmenhaara on her experiments with red clay, can be obtained by writing to her at the Ateneum.

SAND-CASTING Anders Liljefors, a Swedish potter, has become widely known in Scandinavia for his experiments in sand-casting with a type of clay that is ordinarily used to make bathroom fixtures and tile. He began his work in 1956, as a free artist at A. B. Gustavsberg. His plan was to develop tiles for relief and sculpture in basically the same manner in which the bathroom tile was produced—by casting the liquid clay in a bed of damp sand. Most other potters scoffed at the idea, but Mr. Liljefors continued to struggle with it until he succeeded in producing not only tiles of individual character, but disciplined sculpture of the sort featured in Figures C-13 through C-15.

Using his sand-casting technique, Mr. Liljefors has produced a number of important relief sculptures for public buildings in Sweden. Self-employed now, he is presently trying out different atmospheres in gas-firing, and he is also experimenting with different types of clay, including a high-fired clay with a chamotte base. Other samples of Mr. Liljefors' work are shown in Figures 106 through 108.

CERAMIC RELIEF In Figures 109 and 111 through 119 are examples of ceramic reliefs by Ulla Viotti, a Swedish potter who has done a good deal of work in texturing clay. Most of Miss Viotti's forms have been inspired by memories of rock and sand formations seen during a trip through Israel. To achieve her startling imagery, she uses both

high- and low-firing clay, and such unusual stains as wood juice and tea.

She begins her sculpture with a flat slab of clay, about 5 to 6 centimeters thick, which she thins out to about 1 centimeter with bark, hardwood, and scraps of iron. She then shapes her flattened slab to form contours and ridges, as you see in Figures 118 and 119. Often, the final form will be mounted in wet cement. Miss Viotti has also devised a technique for texturing both sides of the clay slab.

A number of Scandinavian free artists, particularly in Sweden, have become fascinated by the possibilities of ceramic architecture. A leader in this direction is Carl-Harry Stalhane, art director at A. B. Rorstrand. Mr. Stalhane is the designer of the wall relief in the main entrance hall of the Volvo building, a work which depicts various stages in the manufacture of iron ore (see Figure C-10). The blocks for this relief were processed at the Rorstrand factory and then shipped to the building site, where they were then assembled. Another of his works is a ceramic wall weighing over 6 tons and measuring 50 meters in height, which he designed for the Commerce Trust Tower in Kansas City, Missouri. His dream, Mr. Stalhane tells me, is to one day do an entire room of ceramic tiles—an environment in clay.

Another pioneering work in architectural relief is the ceramic arcade designed for the Tomteboda Institute for the Blind by Swedish sculptor Olle Aldrin. Called the "Touch and Feel Wall," it has a pronounced relief that the blind children follow with their fingers as they go from one building to the other at the institute. The Touch and Feel Wall is a clash of textures and is constructed of stone, plastic, wood,

metal, bristle, concrete, and cane. Sculptor Aldrin built the wall using a variety of techniques, including embossing, turning, forging, sanding, grinding, and polishing, to obtain these unusual textures.

Of the many other outstanding designs in this area, the works of the following two Scandinavian potters are particularly deserving of mention: Rut Bryk of Finland, featured in Figures C-9 and 203 through 205; and Erik Hoglund of Sweden, shown in Figure 206.

BOX SCULPTURE Featured in Figures 124 through 134 is the sculpture of Swedish potter Lillemor Petersson. One of the largest and most intriguing of her works is a box wall called "Blue Road," a triptych, 320 centimeters high and 900 centimeters long and composed entirely of shadow-box frames in which are mounted a variety of white clay forms. Miss Petersson has used a number of different techniques to create her forms: there are solids and slabs; forms textured with fabric; and even a few spaghetti-like configurations made by forcing the clay through a sieve. Most of the ceramics are painted with cobalt or copper oxide to contrast boldly with the blue-black of the background. As you can see, the overall effect is quite startling—almost surreal.

Swedish potter Britt-Ingrid Persson uses cobalt oxide over stoneware, like Miss Petersson, for a stark white effect. She is generally concerned with social protest in her work, and her themes are transmitted through imagery that is graphic and grotesque. (Examples are featured in Figures 135 through 137). Slightly more abstract is "Group," a porcelain sculpture by Bodil and Richard Manz of Denmark (see Figure 110). Lattice-like forms were developed by slicing completely through a clay dome and then separating slices at inter-

vals to form hollows. The outside dome is smooth and unglazed; inside hollows are glazed with iron.

Metal is frequently used by potters to support free-standing sculpture. Birger Kaipiainen of Finland, for example, built his "Bird" (Figure 140) of ceramic beads over a wire skeleton. In this and other pieces, Mr. Kaipianen combines clay ingeniously with glass and mirrors.

In the picture section of this book you will find works by potters of enormous talent—some of whom are mentioned in the text, and others who are not. Unfortunately, in a book of this size it would be impossible to treat in detail every potter who has done outstanding work in his craft. Thus I have attempted to draw your attention to those whose works highlight dominant trends in this vast and ever-growing field. If you have been stimulated to delve deeper into ceramics, then I invite you to sample the books and magazines mentioned in Materials for Further Study, or to write to a potter whose work you favor. Most of these potters know English perfectly, and like craftsmen everywhere, they always welcome free exchange of ideas.

C-1

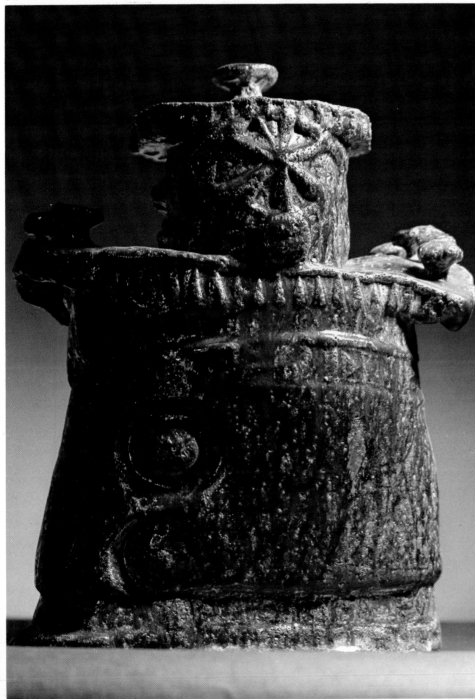

C-1. "Asian Warrior" by Finn Hald of Norway.
Stoneware with iron and ash glaze.
It was fired at 1320° C.

C-2. Sculptured form (front view) in
stoneware chamotte body, painted with
polymer paint. By Myron Brody. (Courtesy of
Wartsila Ab Arabia, Finland.)

C-2

C-3. Sculptured form by Unni Johnson of Norway. (Courtesy of *Bonytt* magazine.)

C-4. Detail of two plates by Friedl Kjellberg for Wartsila Ab Arabia, Finland. Forms were cast in porcelain and fired at about 1377° C. The background piece was glazed with crackle celadon, and the foreground with oxblood.

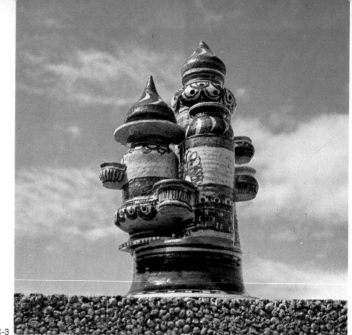

C-3

C-4

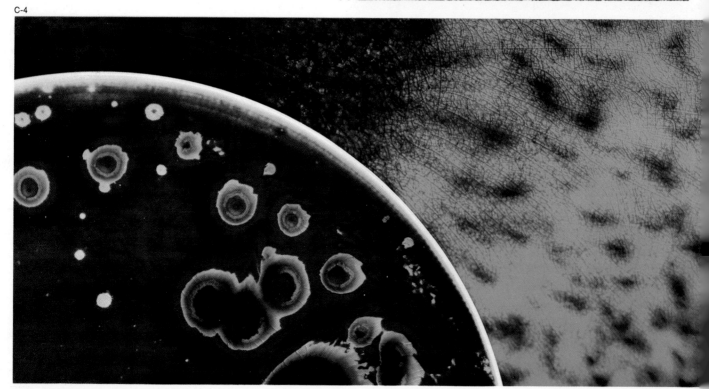

C-5. "Lions," applied relief over slab
construction, 35 by 35 millimeters and fired
at 1320° C. By Dagny Hald of Norway.

C-5

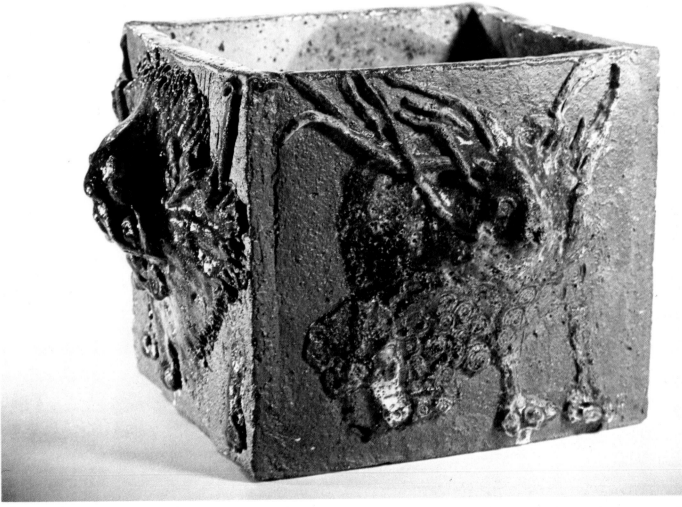

C-6. Wall plaque in chamotte stoneware
body. By Francesca Lindh for Wartsila
Ab Arabia, Finland.

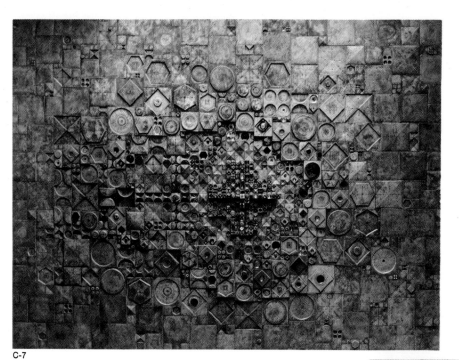

C-7

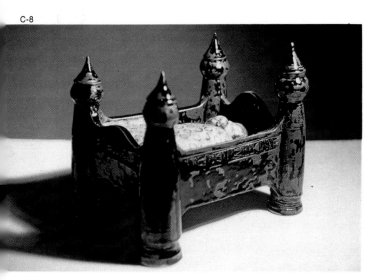

C-8

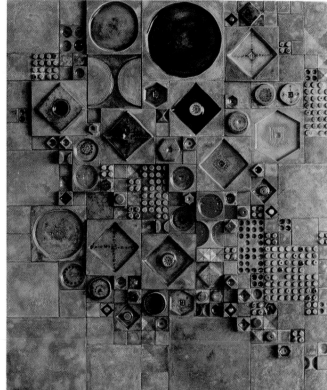

C-9

C-7. Church wall composed of cast ceramic pieces which were surface engraved. The wall is 6 by 9 feet and was designed by Rut Bryk for Wartsila Ab Arabia of Finland. It was fired at about 1066° C.

C-8. ''Peace Monument'' in stoneware by Finn Hald of Norway. The piece was fired at 1320° C. and glazed with iron and ash. It is 25 by 30 millimeters and slab built.

C-9. ''Ahmedabad'' wall plaque by Rut Bryk for Wartsila Ab Arabia of Finland. This relief is 2½ by 3 feet and is made up of small, cast-ceramic pieces which have been surface engraved. The pieces were fired at about 1066° C.

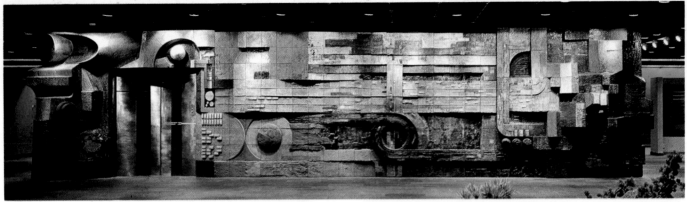

C-10

C-11

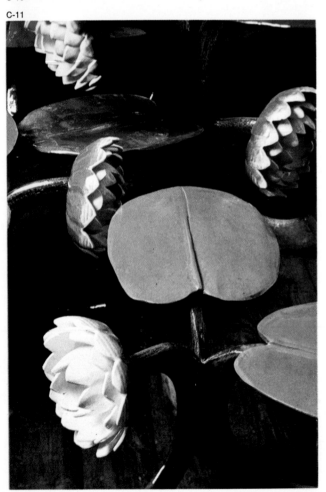

C-12

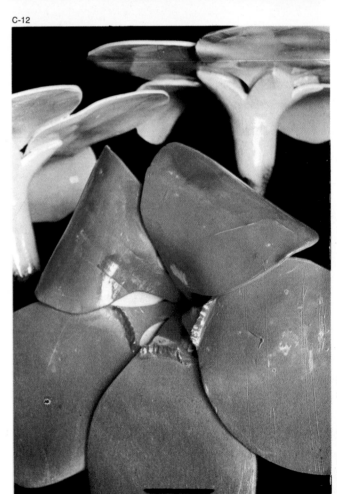

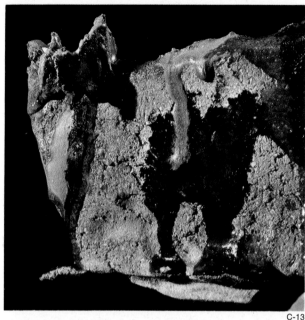

C-13

C-14

C-10. Architectural ceramic relief at the main entrance of the Volvo Aktiebolaget in Goteborg, Sweden. Designed by Carl Harry Stalhane for Rorstrands Porslinsfabriker, Lidkoping, Sweden. The wall is made up of stoneware relief blocks fired at 1400° C.

C-11. "Water Lilies" by Birger Kaipiainen for Wartsila Ab Arabia, Finland. Each form is about 30 centimeters high.

C-12. "Cress Sculptures" by Birger Kaipiainen for Wartsila Ab Arabia, Finland. The forms are 50 to 60 millimeters high.

C-13. Free-form sand-cast sculpture by Anders Liljefors of Sweden. Fired at 1340° C. (Courtesy of Kollegiet for Sverige—Information.)

C-14. Sand-cast free form by Anders Liljefors of Sweden. Fired at 1340° C. (Courtesy of Kollegiet for Sverige—Information.)

C-15. Free-form sand-cast sculpture by Anders Liljefors of Sweden. Fired at 1340° C. (Courtesy of Kollegiet for Sverige—Information.)

C-15

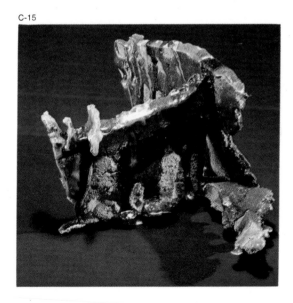

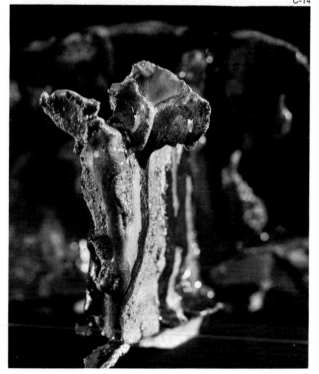

C-16. Bottles by Birte M. Kittilsen of Norway.
Pieces are wheel-thrown with English
earthenware and fired at 1040° C.

C-17. "Angel" by Birger Kaipiainen for
Wartsila Ab Arabia, Finland. This piece
combines a ceramic form with glass inset.

C-18. Thrown earthenware bowl by Birte M.
Kittilsen of Norway. Piece was fired
at 1040° C.

C-19. Red-clay riding horse built with coil
and having horsehair tail and glued leather
saddle. By Catharina Kajander of Finland.

C-16

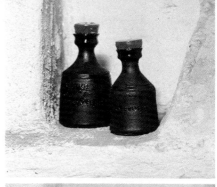

C-17

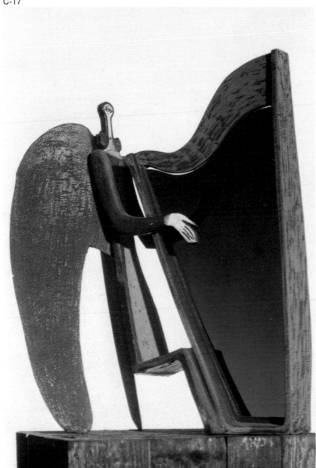

C-18

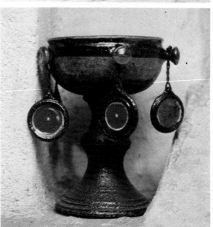

C-19

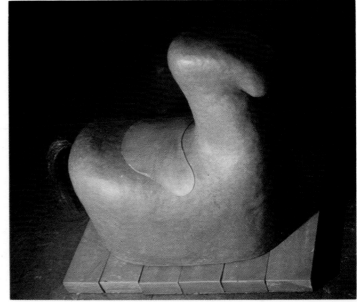

UTILITARIAN CERAMIC WARE

1. Lamp base by Finn Lynggaard of Denmark. (Courtesy of Den Permanente.)

2. Ceramic lamp by Jacob Bang of Denmark. (Courtesy of Den Permanente.)

3. Wheel-thrown chamotte vase by Annikki Hovisaari for Wartsila Ab Arabia, Finland.

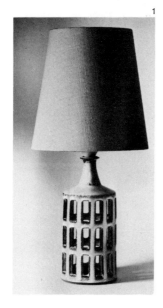

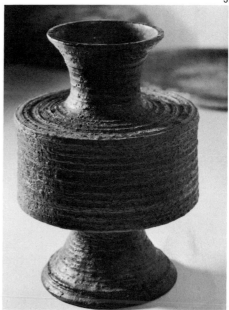

4. Thrown stoneware chamotte by Raija Tuumi for Wartsila Ab Arabia, Finland.

5. Porcelain candlestick, cast and engraved, by Rut Bryk for Wartsila Ab Arabia, Finland. Piece was fired at 1300°C.

6. "Centaur," candlestick and flower vase by Eija Karivirta of Finland. The clay body is stoneware chamotte.

7. "Centaur" (side view) by Eija Karivirta of Finland. The center section was slab-built, the spouts, neck, and feet wheel-thrown, and relief application was added to the head and vest. Piece was fired at 1200°C.

4
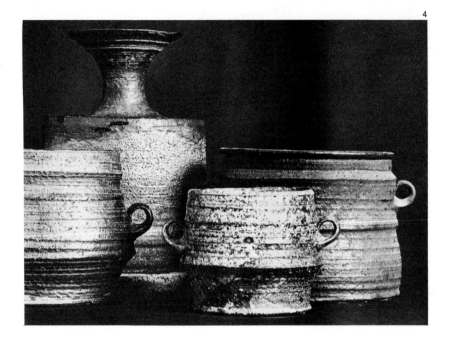

5
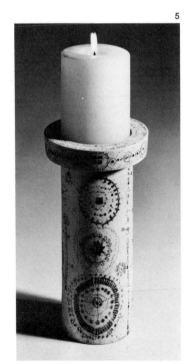

6
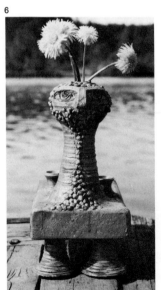

7
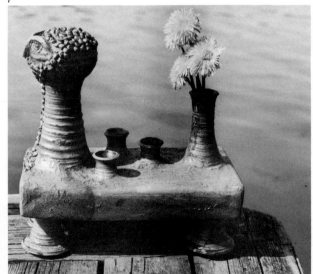

8

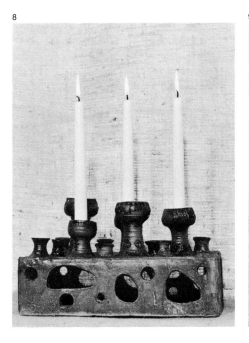

9

8. Candleholder by Eija Karivirta of Finland. The base was slab-built, and the spouts were thrown.

9. Stoneware candleholder by Anna-Maria Osipow of Finland. (Courtesy of the Finnish Design Center.)

10. Candle houses by Signe and John Northroup of Denmark. (Courtesy of the Danish Society of Arts, Crafts, and Industrial Design.)

10

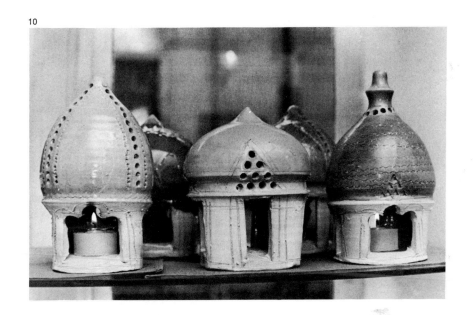

11. Thrown stoneware-chamotte vases by
Raija Tuumi for Wartsila Ab Arabia, Finland.
Piece was fired at 1300°.

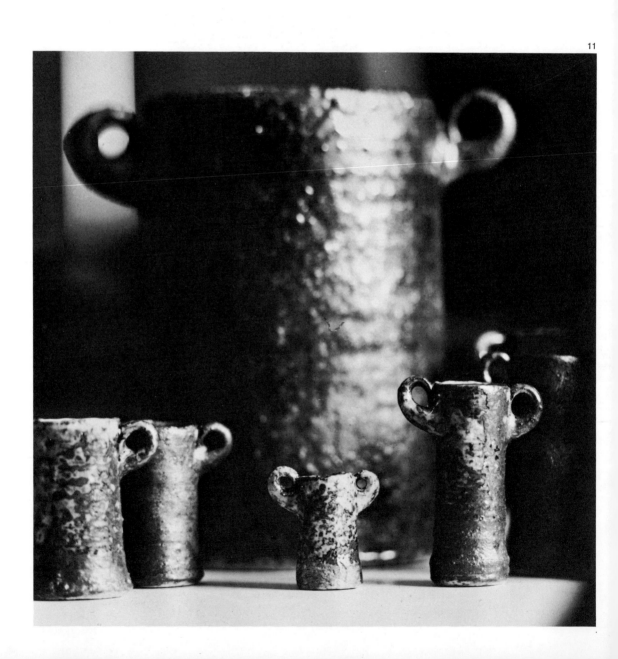

13

12. Detail of pulled and applied handle in stoneware chamotte. By Raija Tuumi for Wartsila Ab Arabia, Finland.

13. Detail of thrown and applied handle on stoneware-chamotte vase. By Francesca Lindh for Wartsila Ab Arabia, Finland.

14. Thrown stoneware-chamotte bottle with hooded vase. By Francesca Lindh for Wartsila Ab Arabia, Finland.

14

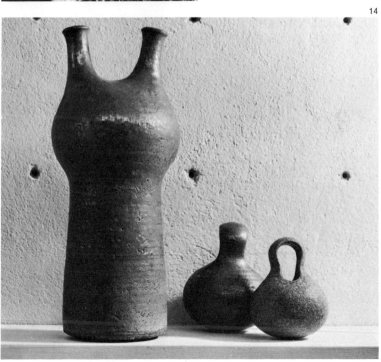

15. Thrown stoneware-chamotte vase and hooded water jug. By Francesca Lindh for Wartsila Ab Arabia, Finland.

16. Thrown stoneware-chamotte covered dish by Annikki Hovisaari for Wartsila Ab Arabia, Finland. Piece was fired at 1300°C.

17. Detail of hooded, thrown pots in stoneware by Francesca Lindh for Wartsila Ab Arabia, Finland. The hood on these forms also functions as the handle.

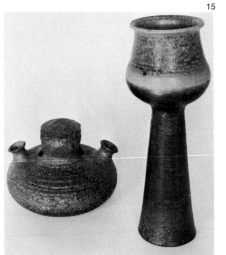

15

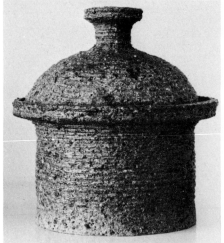

16

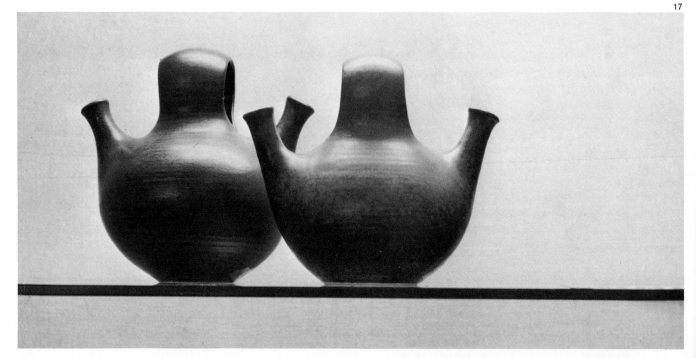

17

18

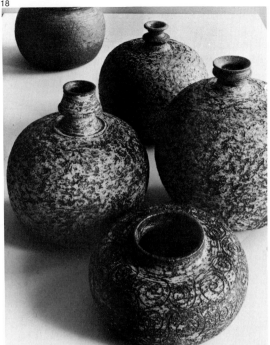

18. Thrown grog vases by Annikki Hovisaari for Wartsila Ab Arabia, Finland. (Courtesy of the Finnish Society of Crafts and Design.)

19. Thrown stoneware-chamotte vases with engraved surfaces by Annikki Hovisaari for Wartsila Ab Arabia, Finland.

19

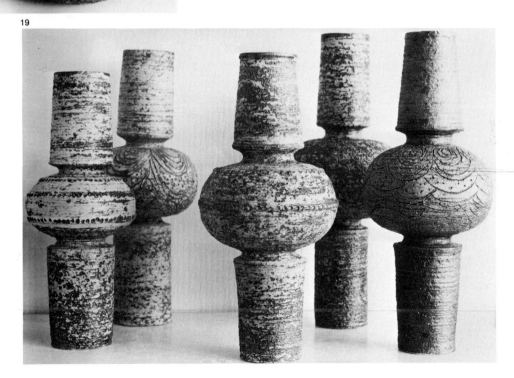

20. Thrown stoneware-chamotte bottles by Kyllikki Salmenhaara for Wartsila Ab Arabia, Finland.

21. Stoneware-chamotte vase by Annikki Hovisaari for Wartsila Ab Arabia, Finland.

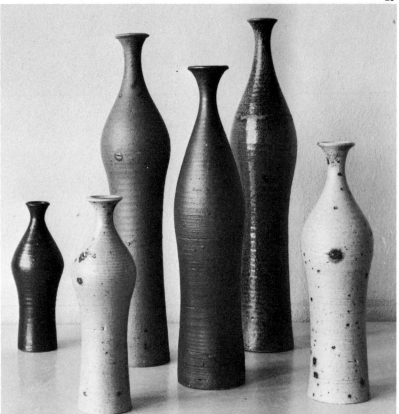

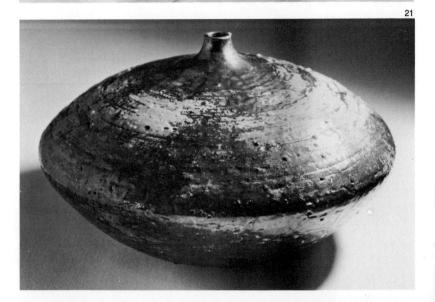

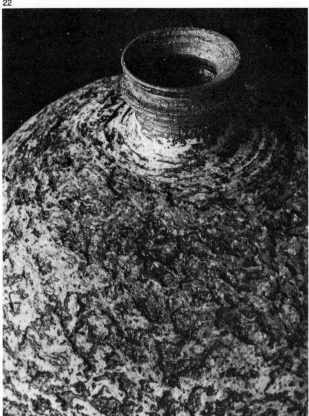

22. Detail of thrown stoneware-chamotte vase by Annikki Hovisaari for Wartsila Ab Arabia, Finland.

23. Thrown stoneware-chamotte vase by Francesca Lindh for Wartsila Ab Arabia, Finland. Piece was fired at 1375°C.

24. Detail of surface on thrown stoneware-chamotte vase (same as Figure 22). By Annikki Hovisaari for Wartsila Ab Arabia, Finland.

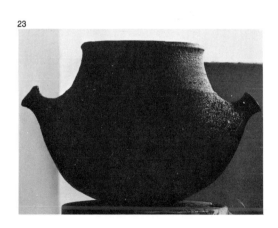

25. Thrown stoneware-chamotte vase by Annikki Hovisaari for Wartsila Ab Arabia, Finland.

26. "Venus of Willendorf," wine bottle in stoneware. By Eija Karivirta of Finland. (Courtesy of the Finnish Design Center.)

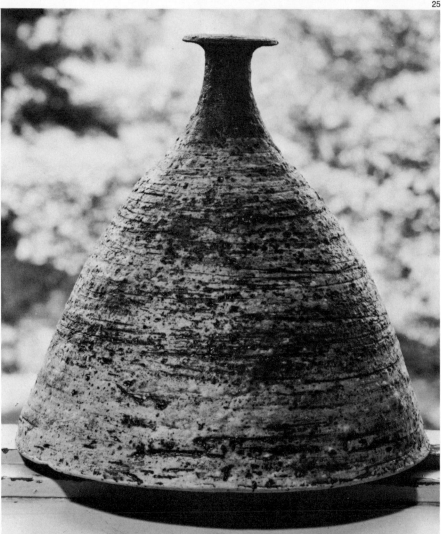

26

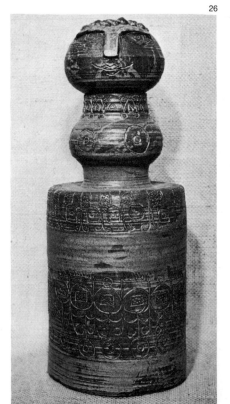

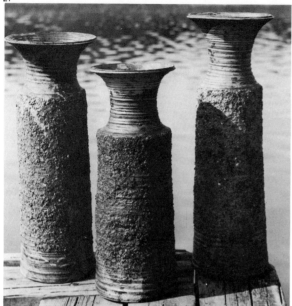

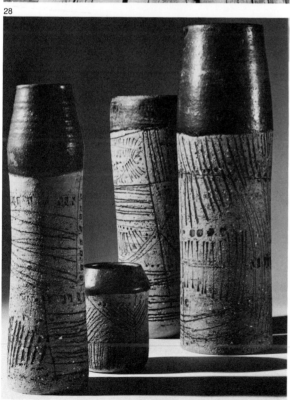

27. Thrown chamotte-stoneware vases by Eija Karivirta of Finland.

28. Thrown stoneware-chamotte vases by Lisa Larsson of Sweden. Top of vase is glazed; unglazed portion is engraved. (Courtesy of Konstindustriskolan, Goteborg.)

29. Stoneware-chamotte bottle by Annikki Hovisaari for Wartsila Ab Arabia, Finland.

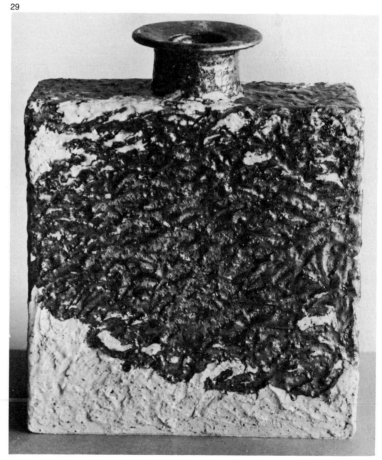

30. Salt-glazed, thrown jar by Nils Kahler of
Denmark. (Courtesy of Den Permanente.)

31. Stoneware weed pot by Anna-Maria
Osipow of Finland.

30

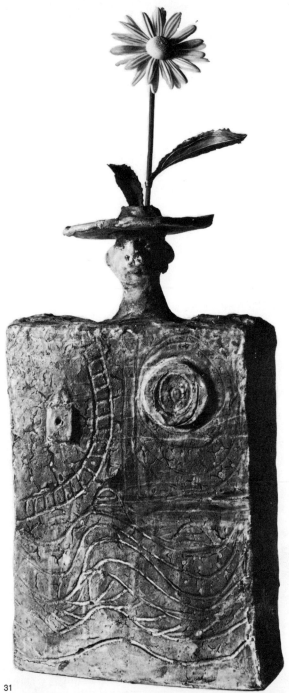

31

32

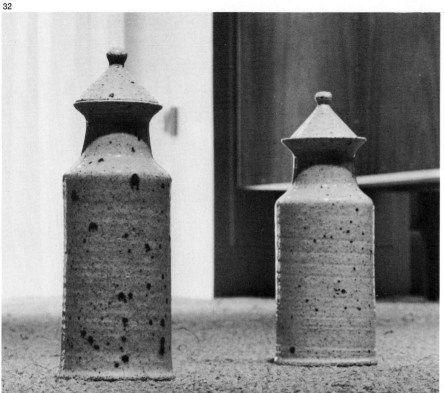

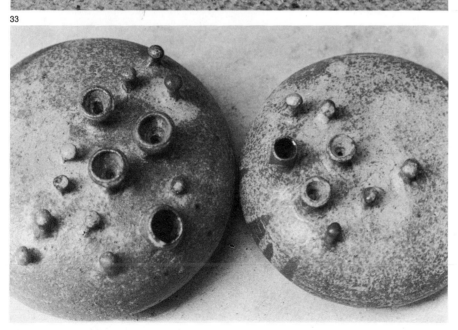

33

32. Stoneware covered jars by Finn Lynggaard of Denmark. (Courtesy of Den Permanente.)

33. Thrown weed pots by Mirja Lukander of Finland. (Courtesy of the Finnish Design Center.)

34. Stoneware bottle by Birthe Weggerby of Denmark. (Courtesy of the Danish Society of Arts, Crafts, and Industrial Design.)

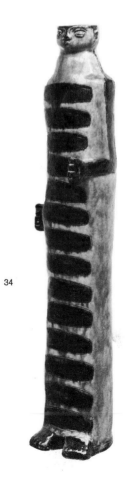

34

35. Thrown stoneware-chamotte bottles by Tue Poulsen of Denmark. (Courtesy of Den Permanente.)

36. Thrown stoneware vessel by Axel Salto of Denmark for the Royal Danish Porcelain Manufactory.

36

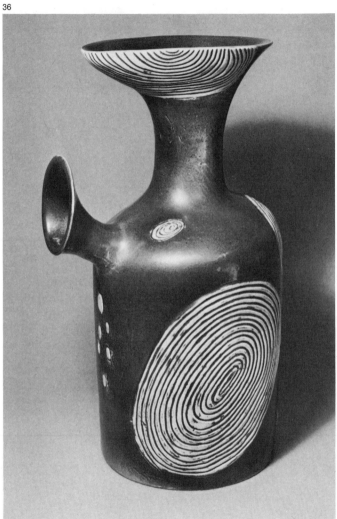

35

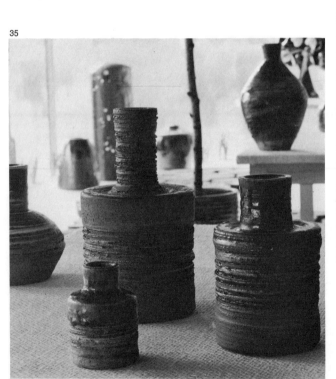

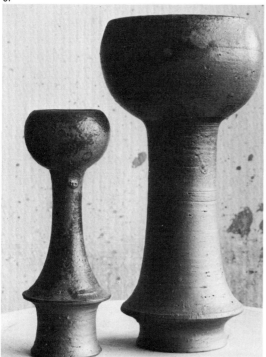

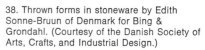

37. Thrown grog vases by Liisa Hallamaa for Wartsila Ab Arabia, Finland.

38. Thrown forms in stoneware by Edith Sonne-Bruun of Denmark for Bing & Grondahl. (Courtesy of the Danish Society of Arts, Crafts, and Industrial Design.)

39. Thrown grog vase glazed with copper and iron oxides. By Kyllikki Salmenhaara for Wartsila Ab Arabia, Finland.

39

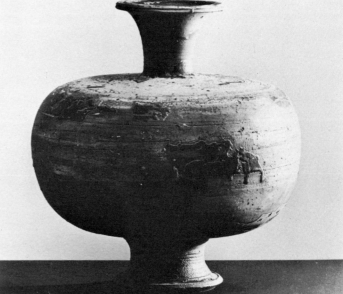

38

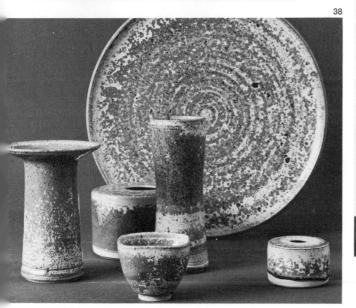

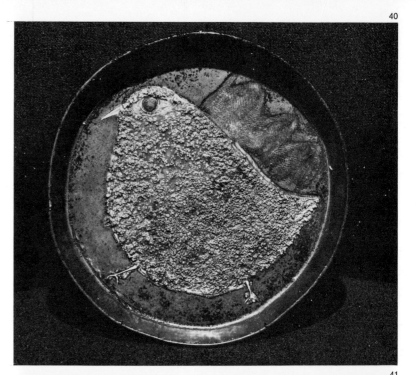

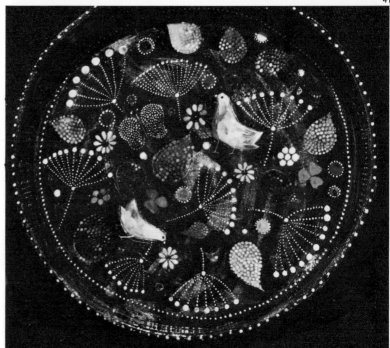

40. Thrown stoneware plate by Sylvia
Leuchovius of Sweden for A. B. Rorstrand.

41. Decorated stoneware plate by Sylvia
Leuchovius of Sweden for A. B. Rorstrand.

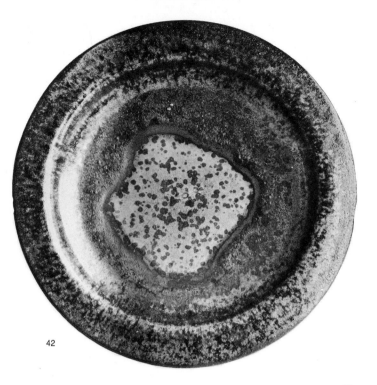

42

42. Thrown plate with copper oxide and stoneware-chamotte body by Toini Muona for Wartsila Ab Arabia, Finland.

43. Copper oxide on stoneware-chamotte plate (detail) by Toini Muona for Wartsila Ab Arabia, Finland.

44. Stoneware plate by Niels Refsgaard of Denmark. (Courtesy of the Danish Society of Arts, Crafts, and Industrial Design.)

43

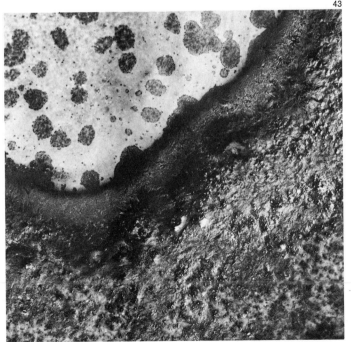

44

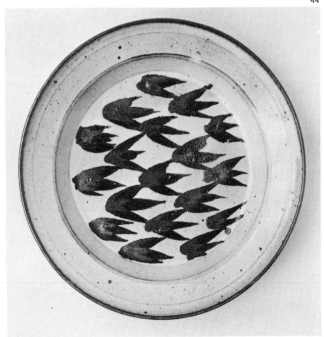

45. Thrown earthenware forms with painted surfaces by Lis Husberg of Sweden.

46. Stoneware plate with iron over celedon by Marianne Westman for A. B. Rorstrand.

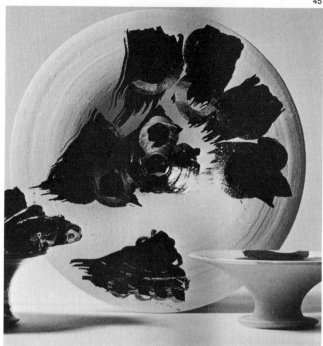

46

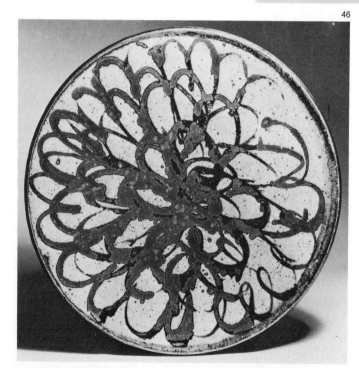

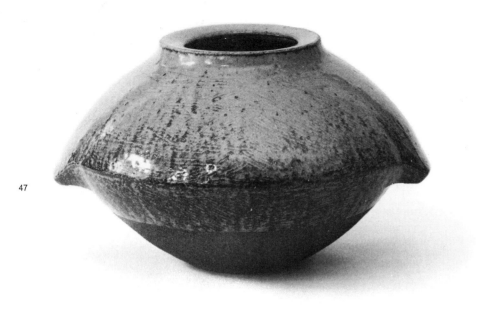

47

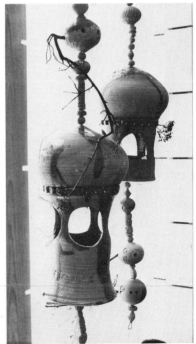

47. Stoneware thrown form by Edith Sonne-Bruun of Denmark for Bing & Grondahl.

48. Stoneware chamotte with engraved surface by Lisa Larsson of Sweden. (Courtesy of Svenska Slojdforeningen.)

49. Thrown stoneware bird feeders by Margareta Swahn-Furtenbach of Sweden. (Courtesy of Svenska Slojdforeningen.)

48

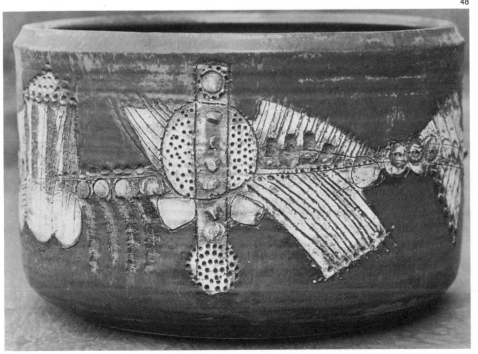

49

50. Unglazed stoneware milk pitcher by Peder Rasmussen. (Courtesy of the Danish Society of Arts, Crafts, and Industrial Design.)

51. Stoneware thrown pitchers with unusual pinched spouts. By Helle Allpass of Denmark. (Courtesy of the Danish Society of Arts, Crafts, and Industrial Design.)

52. Engraved stoneware teapot by Signe Persson-Melin of Sweden. (Courtesy of Svenska Slojdforeningen.)

53. Rice porcelain with transparent glaze by Friedl Kjellberg for Wartsila Ab Arabia, Finland. The individual pieces are mold-built and fired at 1380°C. The ricelike holes are pierced through the walls and filled with a transparent glaze.

54. Rice porcelain with transparent glaze by Friedl Kjellberg for Wartsila Ab Arabia, Finland.

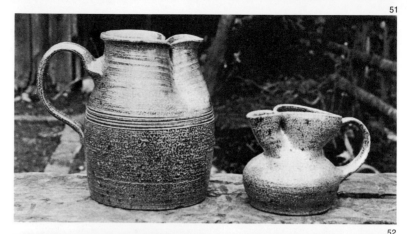

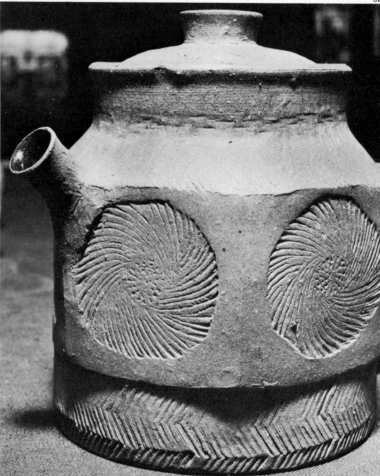

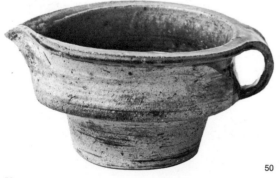

50

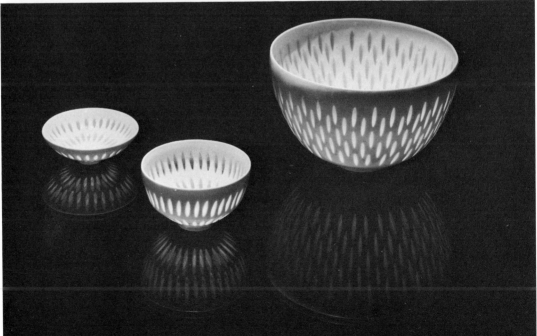

55. Cream jar by Sara Scholdstrom of Finland. (Courtesy of the Finnish Design Center.)

56. Vase, 40 millimeters high, by Toini Muona for Wartsila Ab Arabia, Finland.

57. Stoneware-chamotte bowl by Raija Tuumi for Wartsila Ab Arabia of Finland. It is about 15 centimeters high, wheel-thrown, and fired at 1385°C.

55

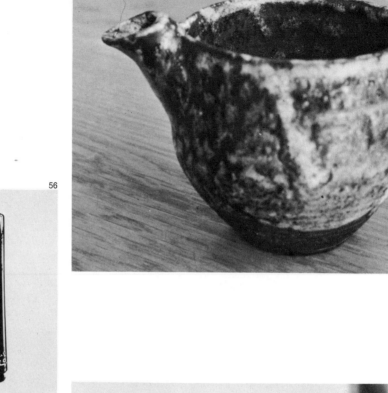

56

57

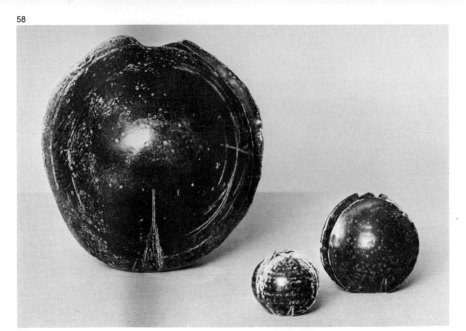

58. Stoneware vases by Gerd Hiort Petersen for the Royal Danish Porcelain Manufactory.

59. Stoneware jar by Turid Mjelve of Norway. (Courtesy of *Bonytt* magazine.)

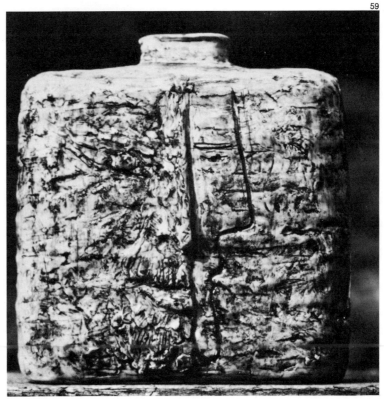

TO19642

60. Porcelain vases by Toini Muona for Wartsila Ab Arabia, Finland.

61. A variety of surface textures by Bengt Berglund for Gustavsberg of Sweden.

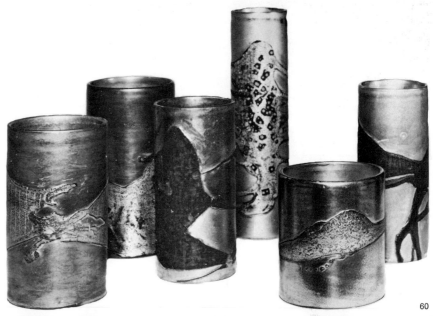

60

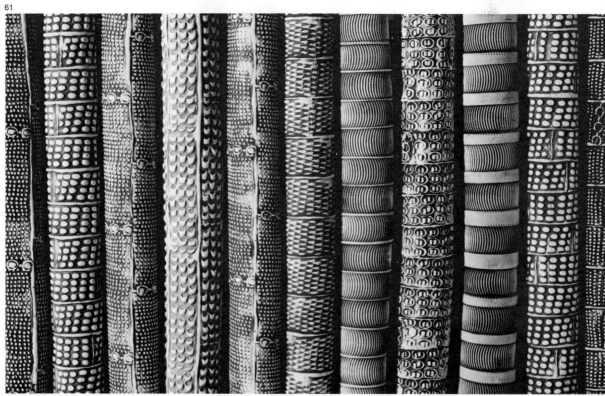

61

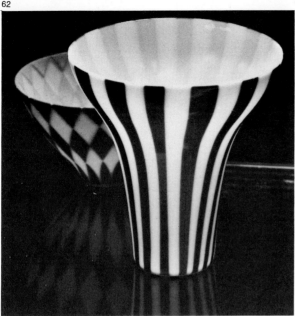

62. Porcelain vases, cast in layers and clear-glazed. By Aune Siimes for Wartsila Ab Arabia, Finland. Pieces were fired at 1380°C.

63. Ceramic stoneware bottles by Erik Ploen of Norway.

64. Stoneware jars by Hertha Bengtson of Sweden for A. B. Rorstrand.

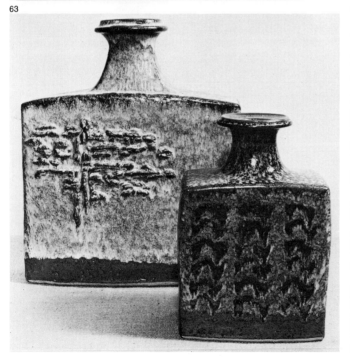

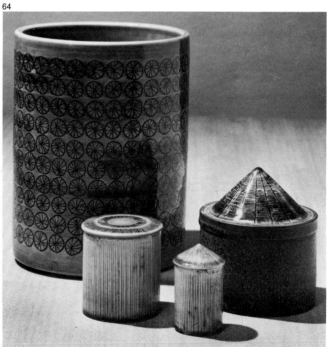

65. Stoneware eggs by Hans Hedberg of Sweden. (Courtesy of Svenska Slojdforeningen.)

66. Thrown stoneware forms with unusual covers by Hertha Bengtson for A. B. Rorstrand.

67. Thrown stoneware forms by Hertha Bengtson for A. B. Rorstrand.

65
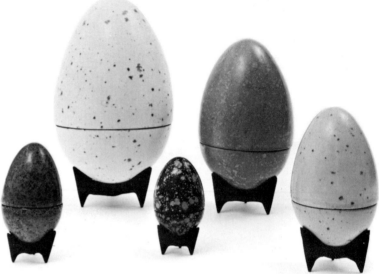

66
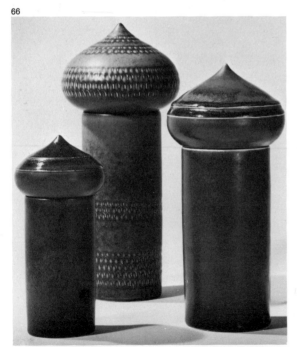

67
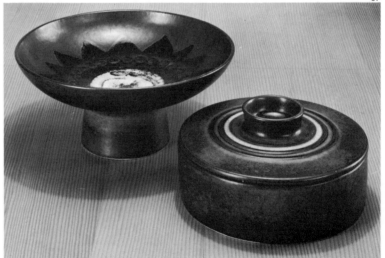

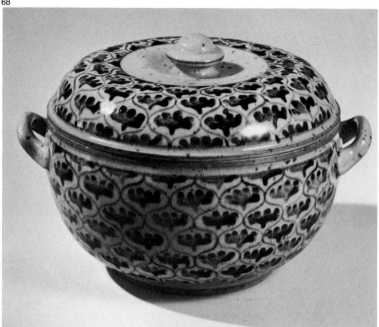

68. Thrown stoneware covered dish by Getrud Vasegaard of Denmark for Bing & Grondahl.

69. Part of a porcelain dinner set by Henning Koppel of Denmark for Bing & Grondahl.

69

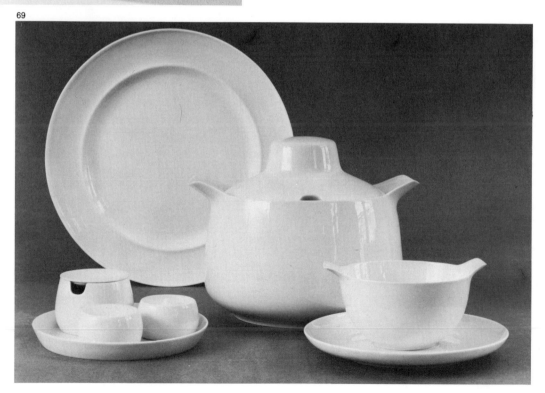

70. Feldspar porcelain forms with thermo-double walls. By Erik Magnussen of Denmark for Bing & Grondahl. The dinner plate also serves as a bowl cover.

71. Stoneware tea service by Tue Poulsen of Denmark. (Courtesy of Den Permanente.)

72. Tea service by Edith Nielsen of Denmark. (Courtesy of Den Permanente.)

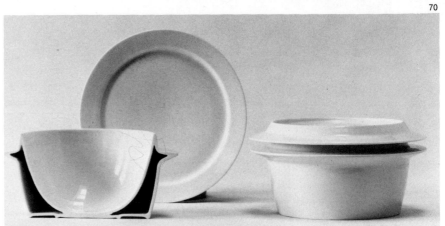

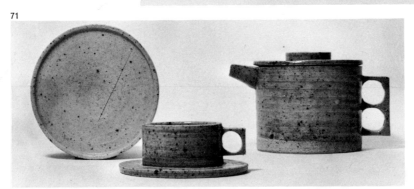

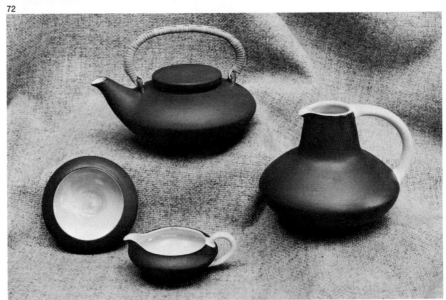

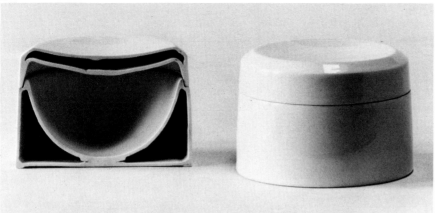

73. Cross-section of thermo-porcelain form by Erik Magnussen of Denmark for Bing & Grondahl.

74. Feldspar thermo-porcelain forms by Erik Magnussen of Denmark for Bing & Grondahl.

74

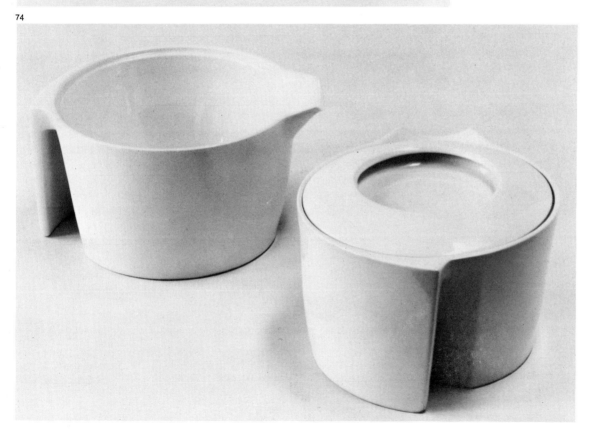

75. New forms from stoneware and porcelain molds by Bente Hansen of Denmark for Bing & Grondahl. The white porcelain form is a cream pitcher.

76. Ashtray with wind cover by Erik Magnussen of Denmark for Bing & Grondahl.

75

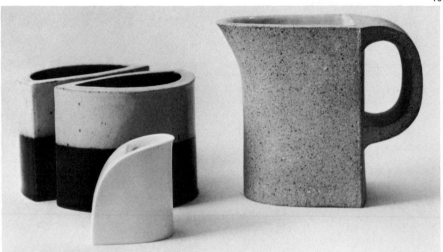

76

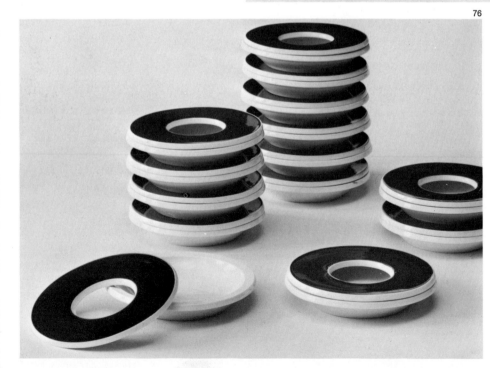

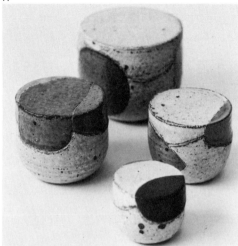

77. Covered stoneware jars by Bente Hansen of Denmark for Bing & Grondahl. The bottom edge of the cover is shaped to follow the decorative motif.

78. Stoneware pepper mills designed without any metal parts. By Erik Magnussen of Denmark for Bing & Grondahl.

79. Unglazed stoneware teapots by Erik Magnussen of Denmark for Bing & Grondahl.

78

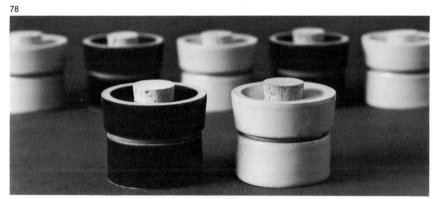

79

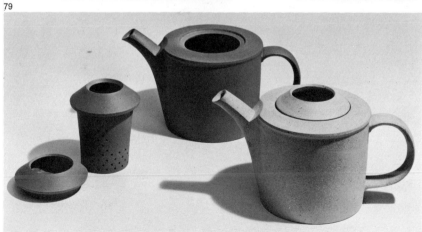

80. Relief engraving on earthenware by Lars Thirslund of Denmark. (Courtesy of the Danish Society of Arts, Crafts, and Industrial Design.)

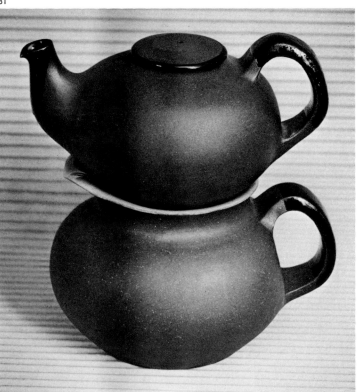

81. Stoneware teapot and water jug by Chr. Poulsen of Denmark. (Courtesy of the Danish Society of Arts, Crafts, and Industrial Design.)

82. Stoneware bowls by Trude Barner Jespersen of Denmark for Bing & Grondahl.

82

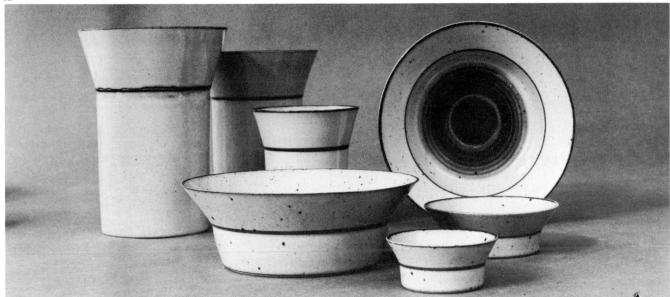

83. Fireproof cooking pots with matte glaze made for Wartsila Ab Arabia, Finland. Forms were cast and molded and fired at 1300°C.

84. Stoneware tea or water pot by Richard Lindh for Wartsila Ab Arabia, Finland. The form was cast and fired at 1300°C.

85. Fireproof cooking pots with matte glaze made for Wartsila Ab Arabia, Finland.

84

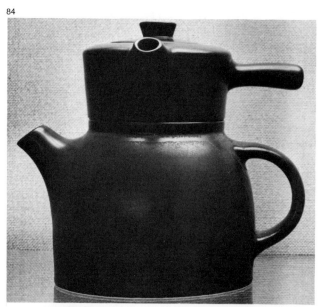

85

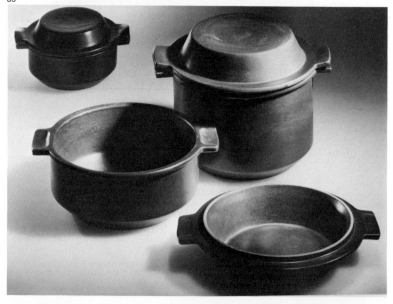

83

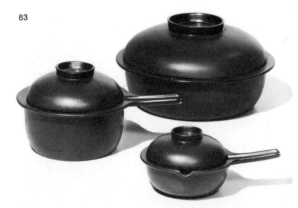

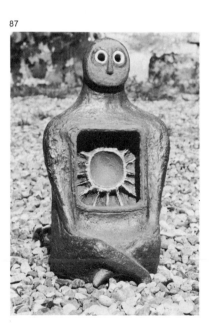

86

EXPERIMENTS
IN RED CLAY

86. Unglazed red clay relief with glass application by Anne Lagergren of Sweden. (Courtesy of Konstindustriskolan, Goteborg.)

87. Red clay sitting man by Lizzie Schnakenburg of Denmark. (Courtesy of the Danish Society for Arts, Crafts, and Industrial Design.)

88. "Four Mothers," red clay form by Lizzie Schnakenburg of Denmark. Piece was fired at 1100°C. (Courtesy of the Danish Society of Arts, Crafts, and Industrial Design.)

87

88

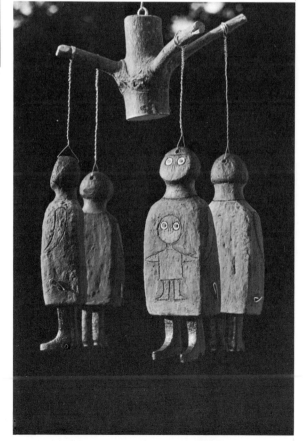

89. The traditional use of Finnish red clay for floor tiles, chimney liners, and bricks.

90. Smoke-fired red clay lamp base by Ulla Saulivaara of Finland. (Courtesy of Ateneum.)

91. Smoke-fired red clay lamp base (detail) by Ulla Saulivaara of Finland. (Courtesy of Ateneum.)

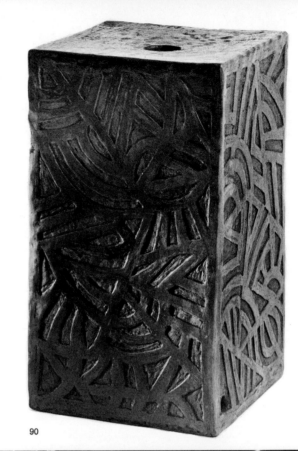

90

89

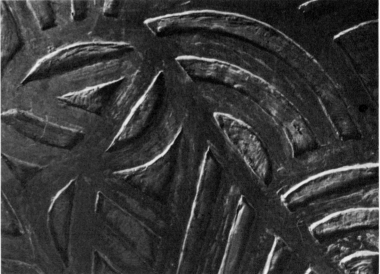

91

92. Red clay relief pieces with contrasting surfaces of smoke-fired and regularly fired clay. By Heikki Orvola of Finland. (Courtesy of Ateneum.)

93. "Soldier," covered jars cast from a mold in red clay. By Catharina Kajander of Finland. The same clay body was used in all of the pieces, but different methods of glazing and firing were used for special effects.

92

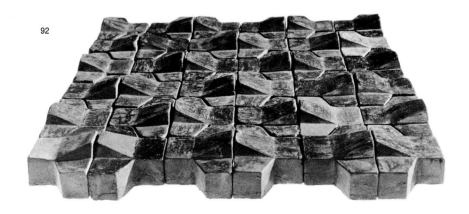

93

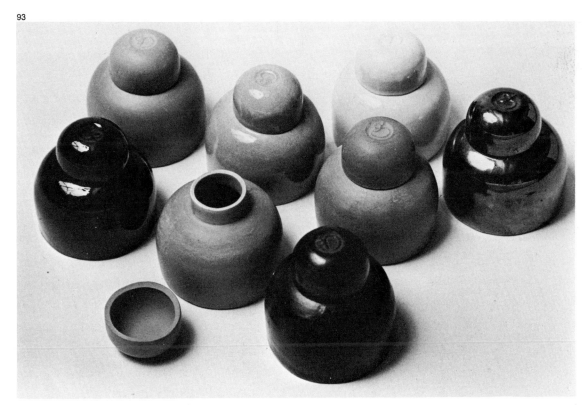

94. Wheel-thrown red clay teapot by Catharina Kajander of Finland.

95. Coil-built, regularly fired red clay flower pot was polished with the backside of a spoon when it had become leather-hard. By Catharina Kajander of Finland. Piece is unglazed.

96. "Birdman," coil-built, unglazed red clay form by Catharina Kajander of Finland.

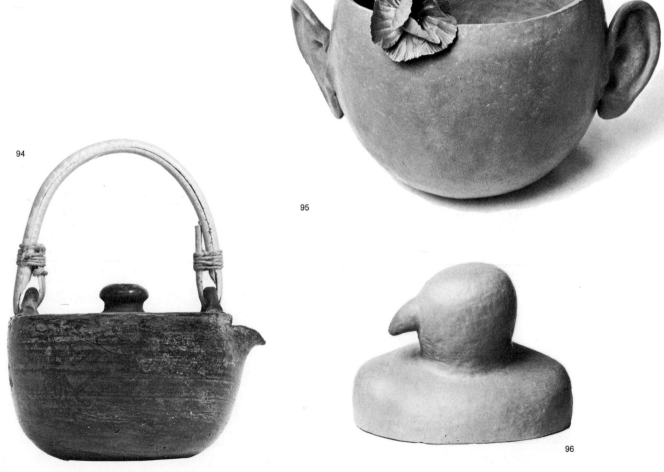

94

95

96

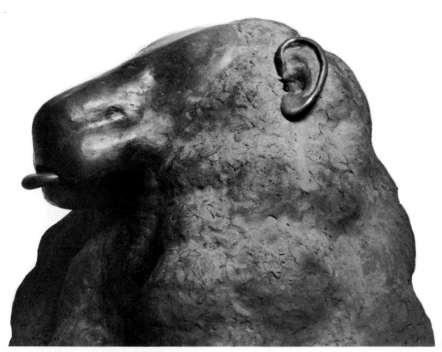

97. "Lionman," unglazed, regularly fired red clay form by Catharina Kajander of Finland. The piece is coil-built, and the face and ear ridges were polished with the backside of a spoon.

98. "Brothers," coil-built, unglazed form by Catharina Kajander of Finland. The same clay body was used for all pieces, but the two outside pieces were smoke-fired. Surfaces were polished before firing.

97

98

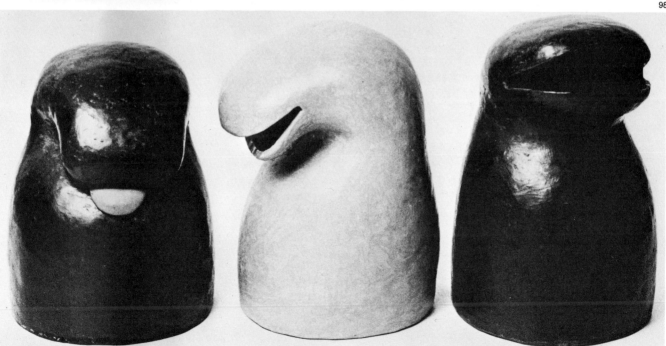

99. Smoke-fired red clay bottle by Leena Kangasmeini of Finland. Piece is unglazed and was polished before firing. (Courtesy of Ateneum.)

100. Chess set in red clay by Catharina Kajander of Finland. One set of chessmen was smoke-fired, and the other was regularly fired. Pieces are unglazed.

99

100

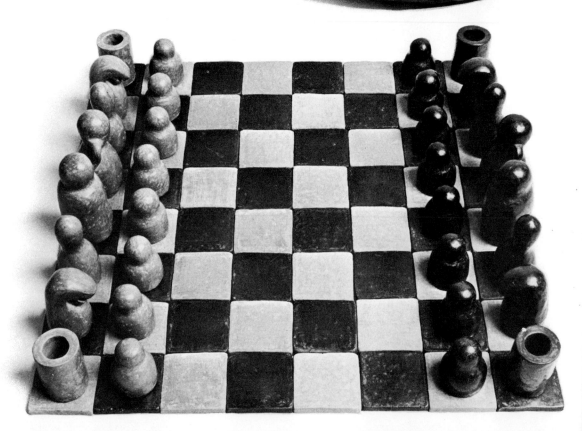

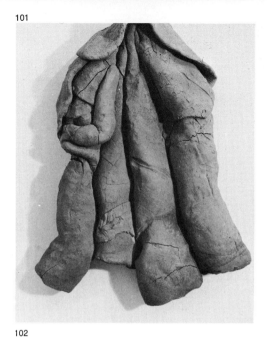

101. "Jacket," slab-built red clay form by Zolton Popovitz of Finland.

102. Three thrown forms by Kyllikki Salmenhaara for Wartsila Ab Arabia, Finland. Forms on right and left were thrown with red clay.

102

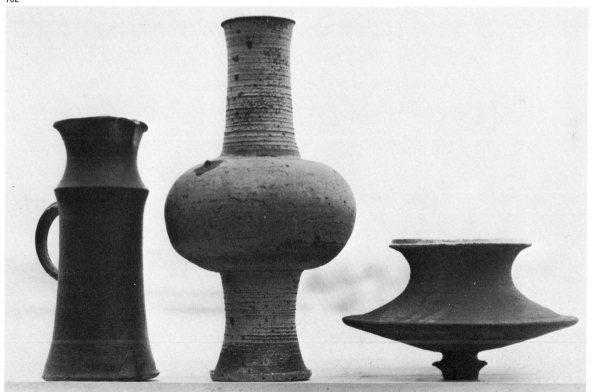

103. Red-clay jars by Kaija Kontiol of
Finland. The clay body is the same on all
three jars, but the jar on the left was fired
with only birch wood; the center jar fired
with electricity; and the jar on the right fired
with wood, using violin rosin in the kiln for
additional smoke. (Courtesy of Kyllikki
Salmenhaara.)

104. Ateneum student smoothing red clay
body with a spoon. (Courtesy of Kyllikki
Salmenhaara.)

105. Close detail of pinch marks on red clay
piece by Ateneum student in Finland.
(Courtesy of Kyllikki Salmenhaara.)

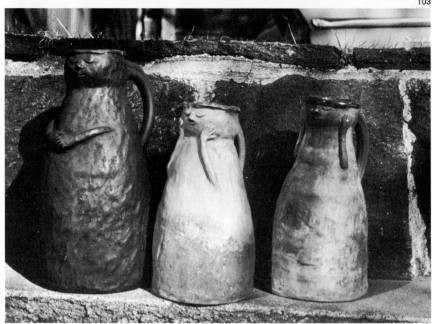

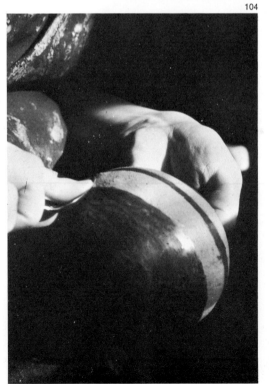

104

105

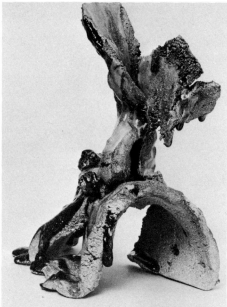

EXPERIMENTS IN SAND-CASTING

106. "Flower," sand-cast sculptural form by Anders Liljefors of Sweden. This free form resulted when Liljefors began to perfect his technique.

107. "Physiognomy," sand-cast relief by Anders Liljefors of Sweden. This piece was fired at 1340°C. using a barium glaze with copper.

108. Sand-cast sculptural form by Anders Liljefors of Sweden. This was one of the first experimental pieces made by Liljefors casting sanitary-ware clay like wall tiles. Piece is 60 centimeters high.

108

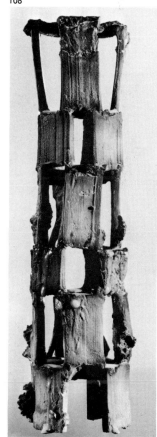

107

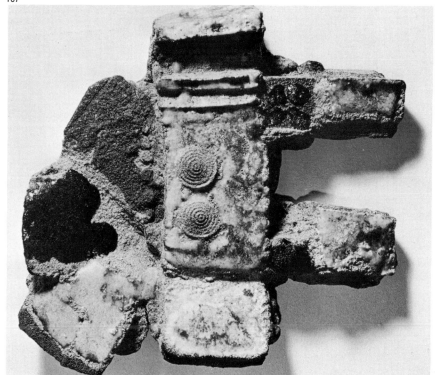

RELIEF AND SCULPTURE

109. "Clay Organ," stoneware sculpture by Ulla Viotti of Sweden was built from a deeply textured slab, formed into tubes and bent. The ceramic forms are glued and mounted on an iron plate.

110. "Group," positive-negative sculptural form by Bodil and Richard Manz of Denmark. This porcelain figure was fired at 1310°C. using an iron glaze in the hollows and no glaze on the outer surfaces.

111. "Clay Organ" (detail) by Ulla Viotti of Sweden.

109

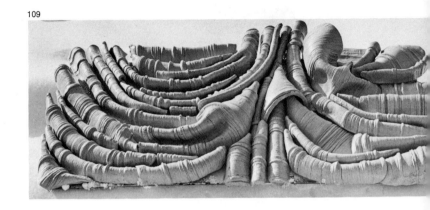

110

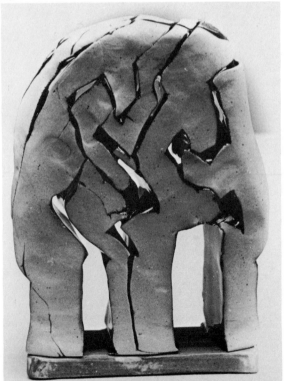

111

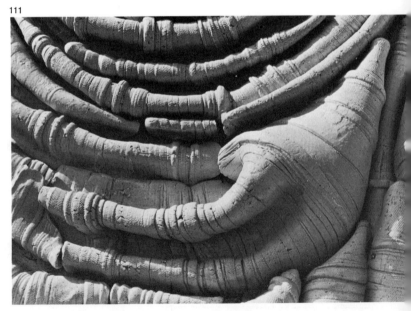

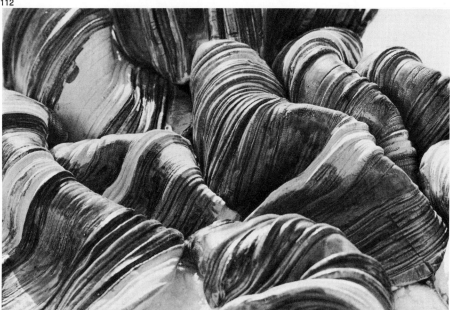

112. "Waves." stoneware relief by Ulla Viotti of Sweden. Pieces of wood, bark, and numerous tools were pressed into the clay slab to develop texture.

113. Low-fired, clay wall relief by Ulla Viotti of Sweden. Piece was fired at 1000°C. and textured with wood and bark.

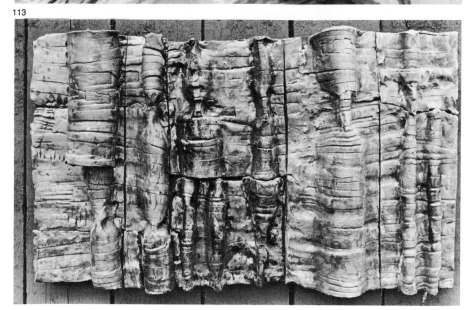

114. Low-fired wall relief (detail) by Ulla Viotti of Sweden.

115. "Mummies" by Ulla Viotti of Sweden. Forms are made out of a variety of low-fired clay bodies which were dipped into strong tea and smoked after the initial firing. Each separate mummy was mounted in wet cement.

116. "Human," green-glazed stoneware by Ulla Viotti of Sweden.

117. "Slaveman," stoneware by Ulla Viotti of Sweden. Texture was developed by pressing wood, bark, and tools into the clay slab.

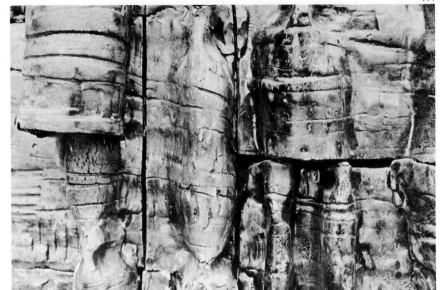

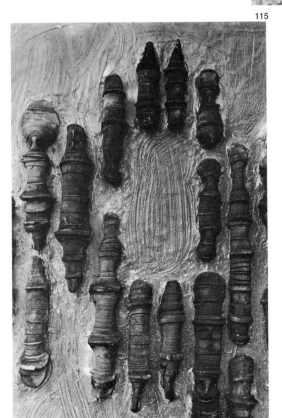

115

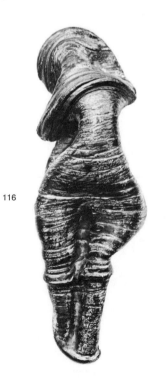

116

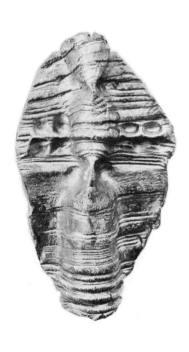

117

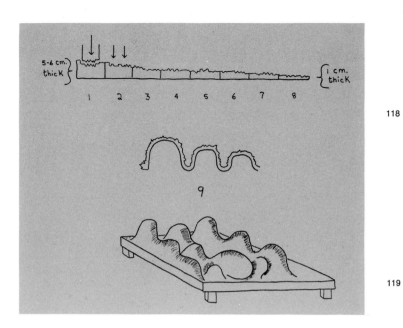

118

119

118. Drawing illustrates the method used by Ulla Viotti to texture and stretch her clay slab into tubelike forms.

119. Illustration of floor-landscape technique used by Ulla Viotti of Sweden.

120. Slab-built bowls, part of an experiment in slab construction by Bengt Berglund for Gustavsberg of Sweden.

120

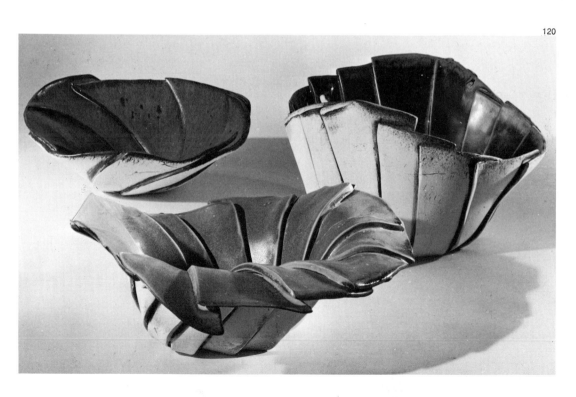

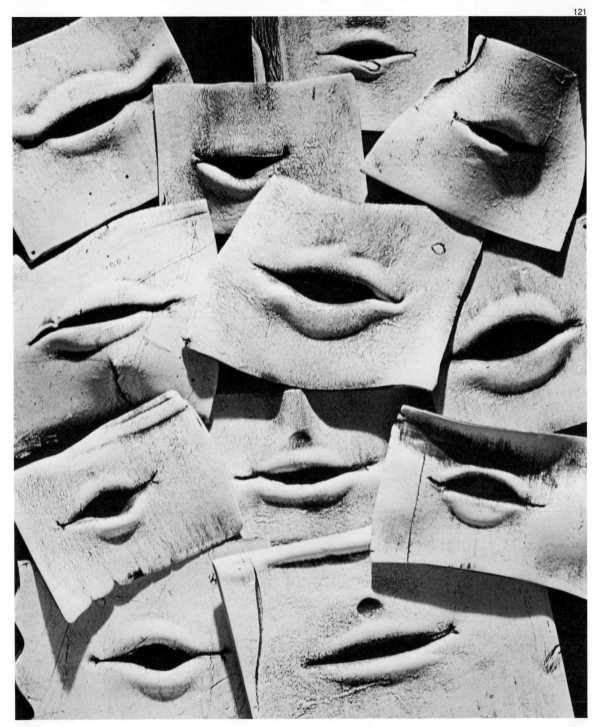

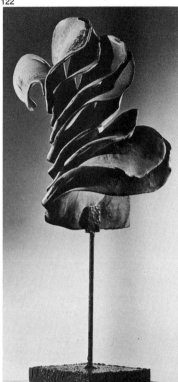

122

121. Slab lips, part of an experiment in slab construction by Bengt Berglund for Gustavsberg of Sweden.

122. Slab-built form, part of an experiment in slab construction by Bengt Berglund for Gustavsberg of Sweden. (Courtesy of the Form Design Center in Malmo.)

123. Slab figures, part of an experiment in slab construction by Bengt Berglund for Gustavsberg of Sweden.

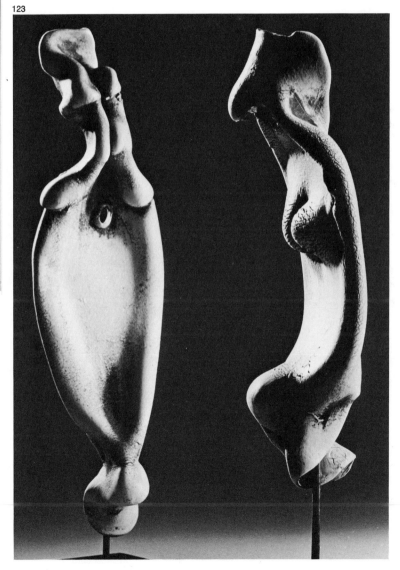

123

124. One section of "Blue Road," a triptych by Lillemor Petersson of Sweden. The whole piece measured 320 by 900 centimeters; it is made up of stoneware forms washed with cobalt oxide and fired at 1280°C. Each form is mounted in a separate box.

124

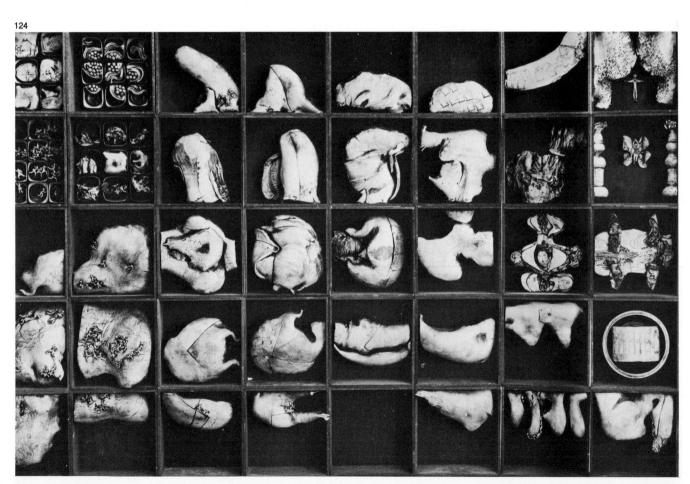

125. "Blue Road" (detail) by Lillemor Petersson of Sweden. Spaghetti-like clay was run through screening.

126. "Blue Road" (detail) by Lillemor Petersson of Sweden.

127. "Blue Road" (detail) by Lillemor Petersson of Sweden

128. "Blue road" (detail) by Lillemor Petersson of Sweden.

129. "Blue Road" (detail) by Lillemor Petersson of Sweden.

130. "Blue Road" (detail) by Lillemor Petersson of Sweden.

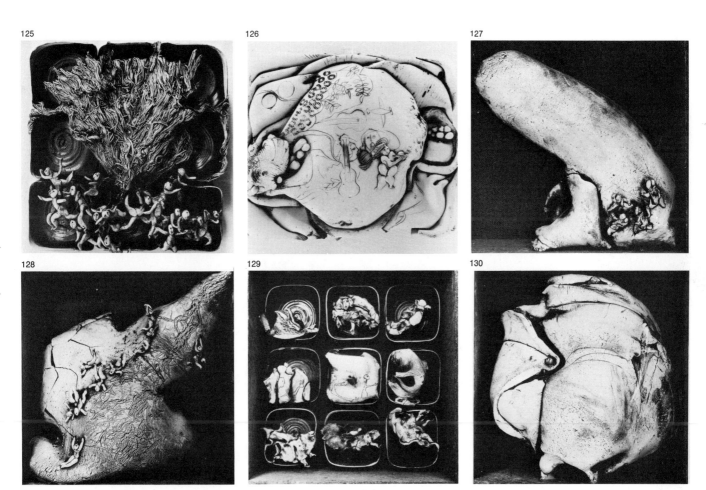

125

126

127

128

129

130

131. Engraved stoneware form by Lillemor Petersson of Sweden. Form was washed with cobalt oxide and fired at 1280°C.

132. Copper oxide wash over engraved stoneware by Lillemor Petersson of Sweden.

133. Engraved stoneware slab forms by Lillemor Petersson of Sweden.

131

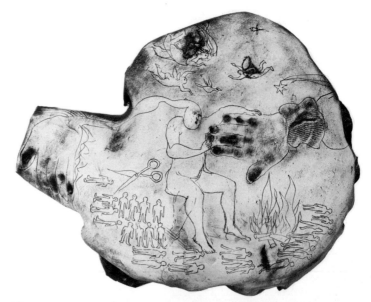

132
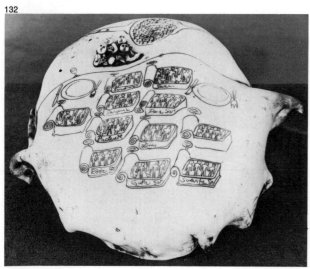

133
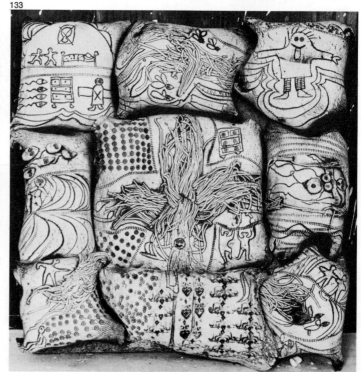

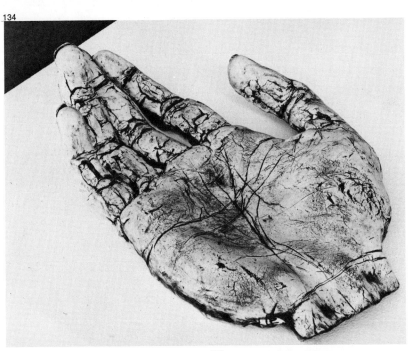

134. Stoneware hand with cobalt oxide wash by Lillemor Petersson of Sweden.

135. "Give Me a Nicer Face" by Britt-Ingrid Persson of Sweden. The form is stoneware painted with cobalt oxide.

136. "Civilized Manipulation" by Britt-Ingrid Persson of Sweden. White stoneware is painted with cobalt oxide.

137. "We Become Specialists without Overlook" by Britt-Ingrid Persson of Sweden. Piece is white stoneware painted with cobalt oxide.

135

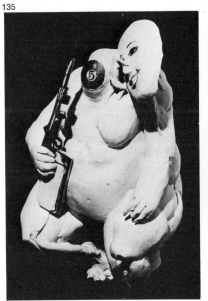

136

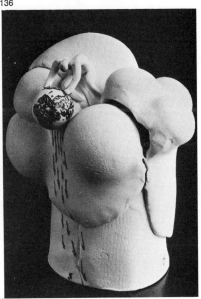

137

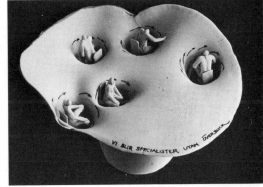

138. "Eggs" by Francesca Lindh for Wartsila Ab Arabia, Finland. Stoneware-chamotte body was wheel-thrown in two parts and then joined. Fired at 1298°C. Color is deep turquoise and lustrous copper.

139. Front view of second bird form by Birger Kaipiainen for Wartsila Ab Arabia, Finland. This piece has small mirrors along with ceramic beads over wire.

140. "Bird" by Birger Kaipiainen for Wartsila Ab Arabia, Finland. Form is composed of small ceramic beads over a wire skeleton. Stand and bill are iron. Fired at 1300°C.

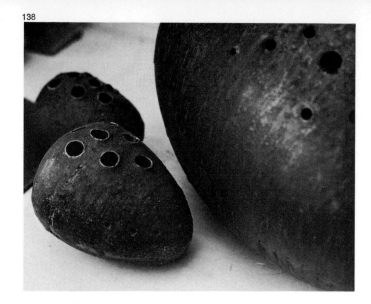
138

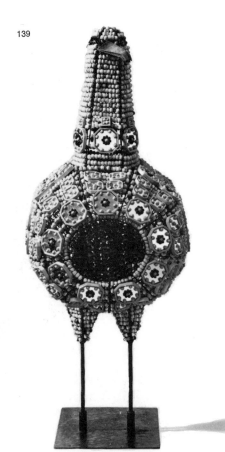
139

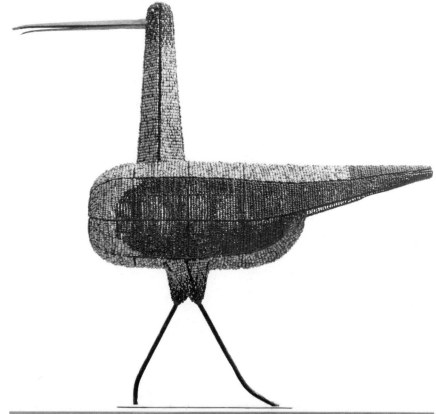
140

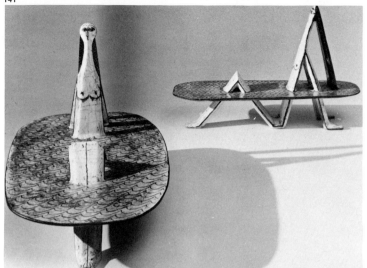

141. "Bathing Women" by Birger Kaipiainen for Wartsila Ab Arabia, Finland.

142. Detail of faïence plate by Birger Kaipiainen for Wartsila Ab Arabia, Finland.

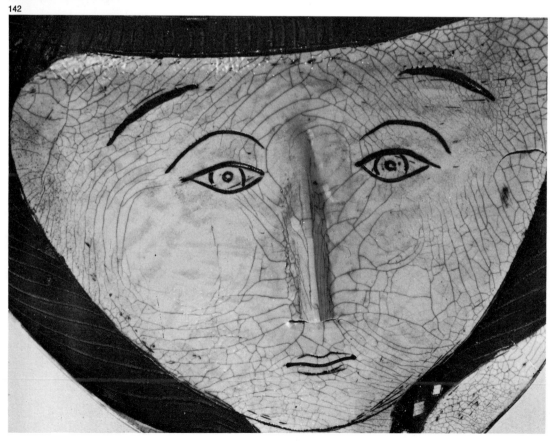

143. "Virgo" by Taisto Kaasinen for Wartsila Ab Arabia, Finland. Engraved chamotte body was fired at 1300°C.

144. "Sagittarius," engraved chamotte zodiac sign by Taisto Kaasinen for Wartsila Ab Arabia, Finland. Piece was fired at 1300°C.

145. "Gemini," chamotte zodiac sign by Taisto Kaasinen for Wartsila Ab Arabia, Finland.

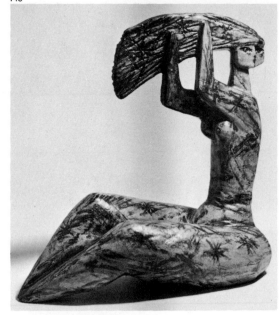

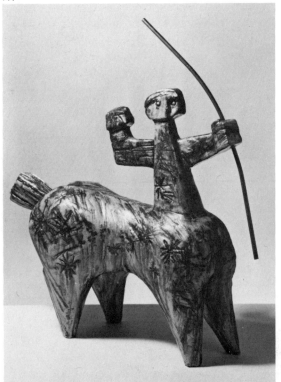

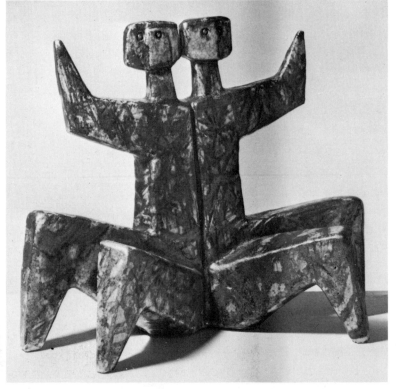

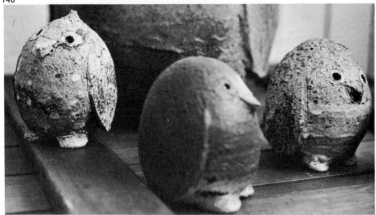

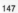

146. "Family of Birds," stoneware-chamotte sculpture by Francesca Lindh for Wartsila Ab Arabia, Finland. Forms were thrown on a wheel, then pierced and engraved. Firing temperature was 1305°C.

147. "Horse," engraved chamotte form by Oiva Toikka for Wartsila Ab Arabia, Finland. Legs, tail, and head were wheel-thrown; body was slab-built. Piece was fired at 1380°C.

147

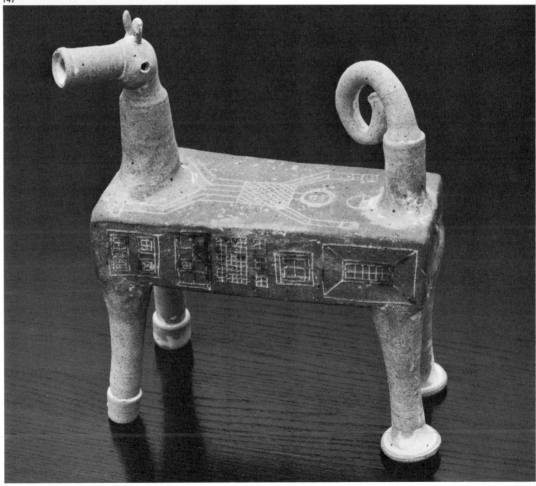

148. "Roosters" by Heljatuulia Liukko-Sundstrom for Wartsila Ab Arabia, Finland. The forms are composed of small, cast pieces joined with slip and glazed matte black and lustrous copper.

149. Chamotte sculpture by Sakari Vapaavuori for Wartsila Ab Arabia, Finland. Piece was fired at 1300°C.

150. "Money Tree" by Heljatuulia Liukko-Sundstrom for Wartsila Ab Arabia, Finland. Form is composed of small cast and engraved pieces joined with slip, glazed a lustrous copper, and fired at 1300°C.

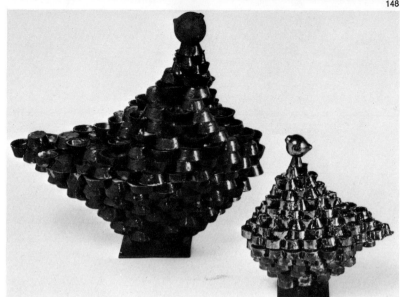

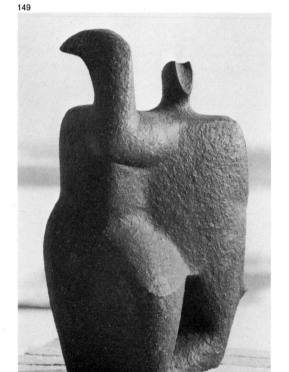

149

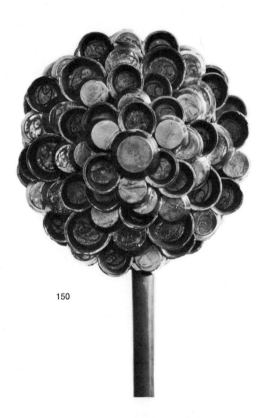

150

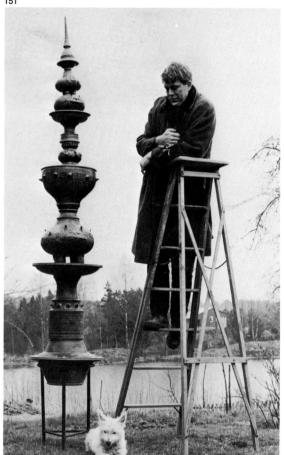

151. Norwegian potter Finn Hald stands next to his stoneware tower. Courtesy of *Bonytt* magazine.)

152. Stoneware-chamotte sculptural forms were slab-built by Gerd Gustafson of Sweden. Pieces were glazed with earthenware slip. (Courtesy of Konstindustriskolan, Goteborg.)

153. "Morning Fly," slab-built form by Bengt Berglund for Gustavsberg of Sweden.

153

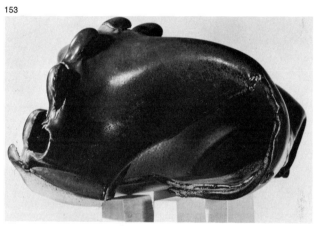

152

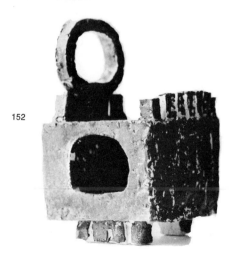

154. Free-form stoneware study inspired by underwater diving near Tunisia. By Carl-Harry Stalhane for A. B. Rorstrand. Glazes include chromium oxide, titanium, and uranium.

155. Free-form stoneware sculpture inspired by underwater diving. By Carl-Harry Stalhane for A. B. Rorstrand. Uranium slip was used with celedon glaze.

156. Free-form stoneware forms inspired by underwater diving. By Carl-Harry Stalhane for A. B. Rorstrand. Glazes used include tenmoku, iron, and uranium slip.

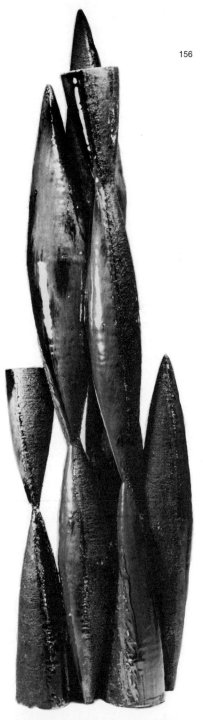

156

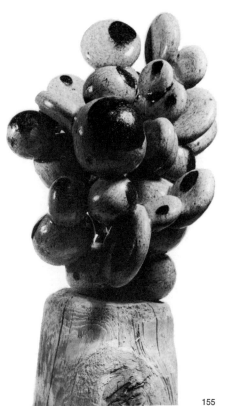

155

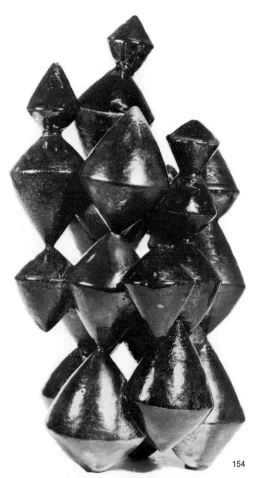

154

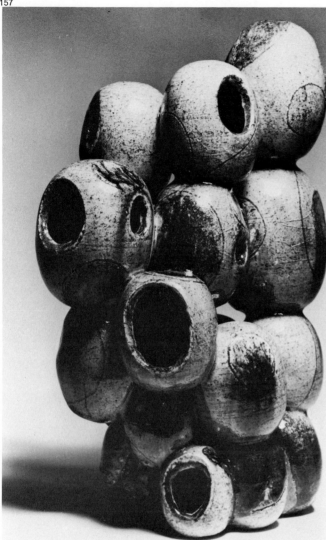

157. Free-form stoneware forms inspired by underwater diving. By Carl-Harry Stalhane for A. B. Rorstrand. Uranium, iron, and titanium glazes were used.

158. Free-form stoneware inspired by underwater diving. By Carl-Harry Stalhane for A. B. Rorstrand. Glazes include rutile, vanadium, and iron.

158

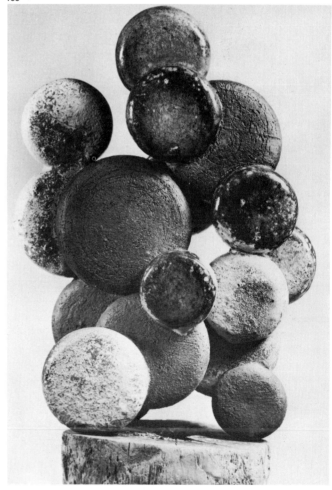

159. Stoneware hand, glazed matte brown.
By Anna-Maria Osipow of Finland.

160. Free-form stoneware inspired by
underwater diving. By Carl-Harry Stalhane
for A. B. Rorstrand. Glazes include titanium
and iron.

161. Stoneware sculpture by Finn Carlsen of
Denmark. (Courtesy of the Danish Society of
Arts, Crafts, and Industrial Design.)

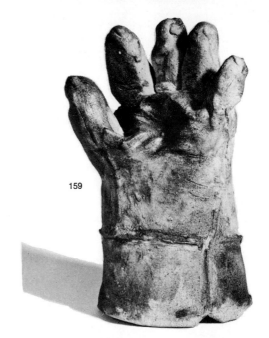

159

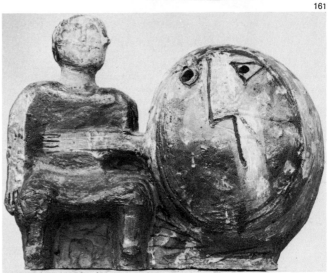

161

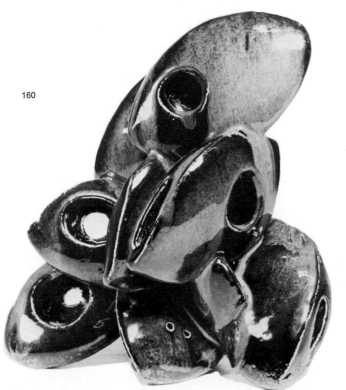

160

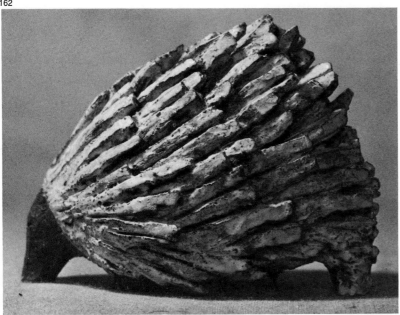

162. Stoneware by Tut Fog of Denmark for Bing & Grøndahl. (Courtesy of the Danish Society for Arts, Crafts, and Industrial Design.)

163. Unglazed stoneware figures by Lizzie Schnakenburg of Denmark. (Courtesy of the Danish Society of Arts, Crafts, and Industrial Design.)

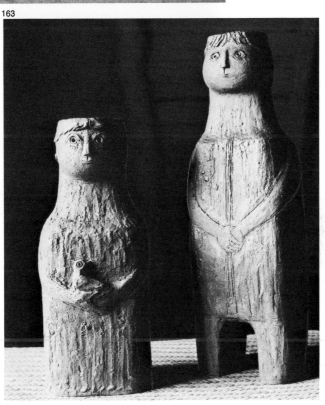

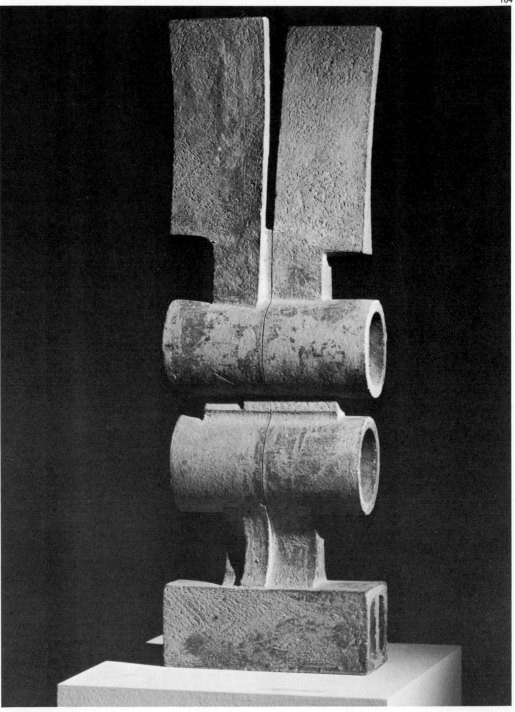

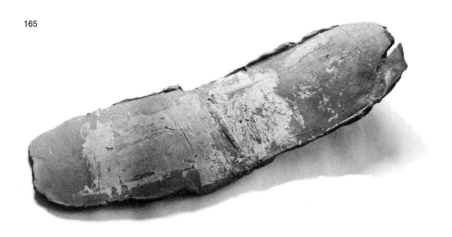

164. Stoneware sculpture by Soren Georg Jensen of Denmark. (Courtesy of the Danish Society for Arts, Crafts, and Industrial Design.)

165. Stoneware form by Erik Magnussen of Denmark for Bing & Grondahl.

166. Stoneware hands by Finn Lynngaard of Denmark. (Courtesy of the Danish Society for Arts, Crafts, and Industrial Design.)

167. Stoneware form by Bente Hansen of Denmark for Bing & Grondahl.

166

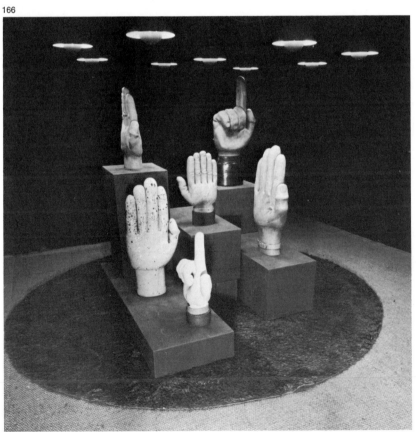

167

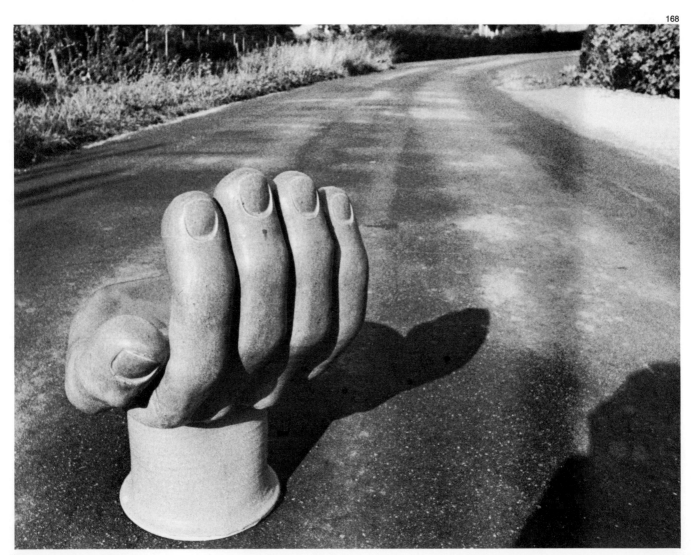

168

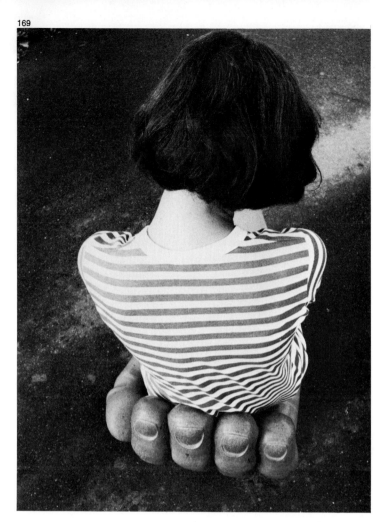

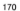

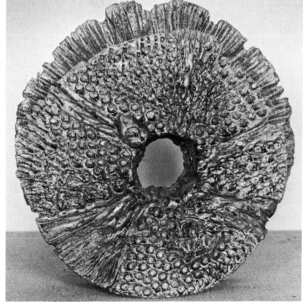

169. Stoneware chair with lady by Finn Lynggaard of Denmark. (Courtesy of the Danish Society for Arts, Crafts, and Industrial Design.)

170. Stoneware sculpture by Erik Reiff of Denmark. (Courtesy of the Danish Society of Arts, Crafts, and Industrial Design.)

171. Stoneware sculpture by Allan Schmidt of Denmark. (Courtesy of the Danish Society for Arts, Crafts, and Industrial Design.)

172. Matte-glazed, thrown stoneware masks by Anna-Maria Osipow of Finland.

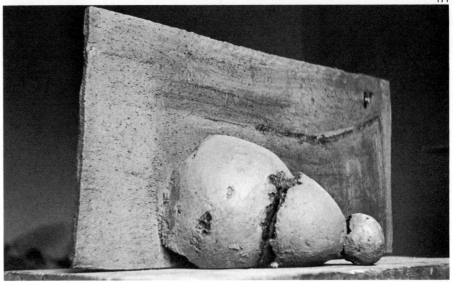

172

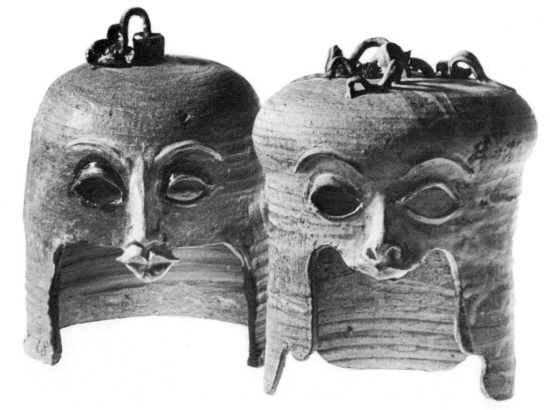

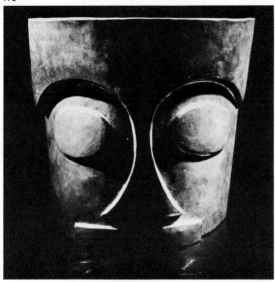

173. Mask by Heidi Blomstedt for Kupittan Savi Oy, Finland. (Courtesy of *Avotakka* magazine.)

174. Stoneware sculpture with slip surface by Tut Fog of Denmark for Bing & Grondahl.

175. Stoneware form by Erik Magnussen of Denmark for Bing & Grondahl.

174

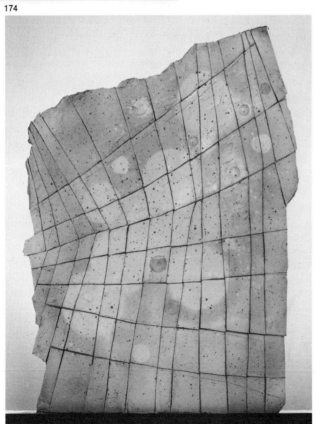

175

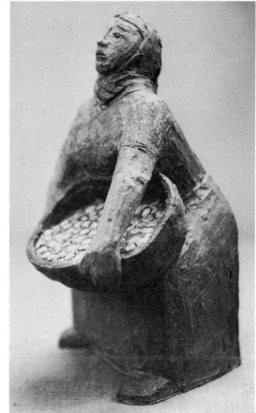

176. Porcelain columns by Erik Magnussen of Denmark for Bing & Grondahl.

177. Stoneware form mounted on iron by Erik Magnussen of Denmark for Bing & Grondahl.

178. Sculpture by Lisa Engqvist of Denmark. (Courtesy of the Danish Society of Arts, Crafts, and Industrial Design.)

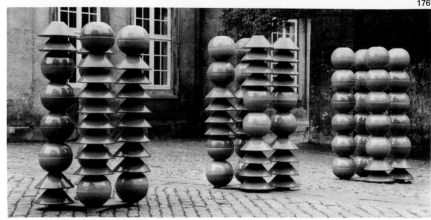

176

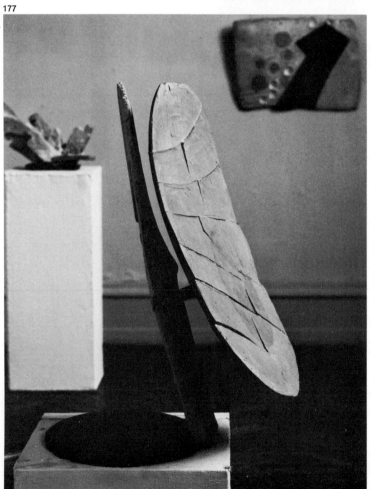

177

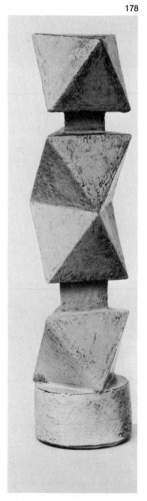

178

179

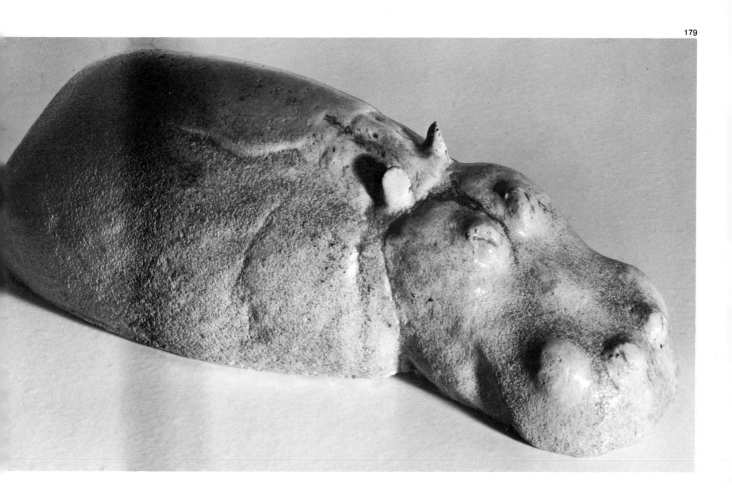

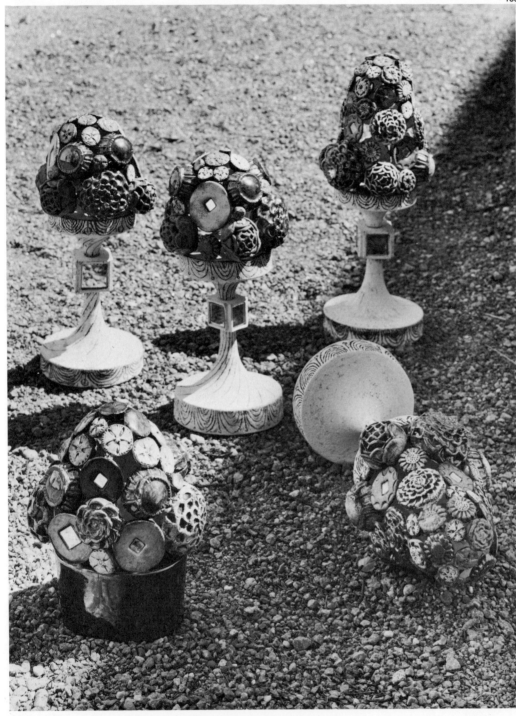

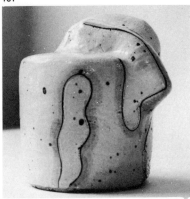

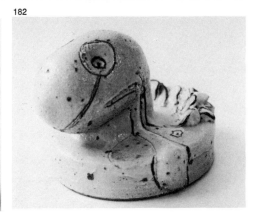

180. Faïence forms with inset mirrors by Birger Kaipiainen for Wartsila Ab Arabia, Finland. (Courtesy of the Finnish Society of Crafts and Design.)

181. Stoneware sculpture with ferric oxide by Sten Lykke Madsen of Denmark for Bing & Grondahl.

182. Stoneware sculpture by Sten Lykke Madsen of Denmark for Bing & Grondahl.

183. Applied relief in unglazed stoneware by Stig Lindberg for Gustavsberg of Sweden.

184. Unglazed stoneware figures by Stig Lindberg for Gustavsberg of Sweden.

184

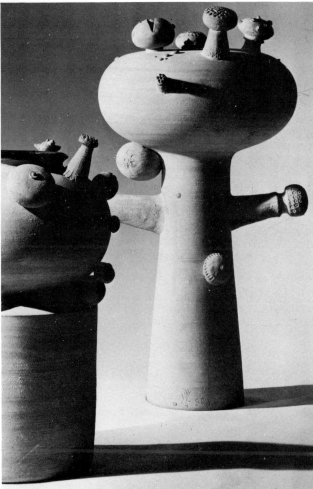

183

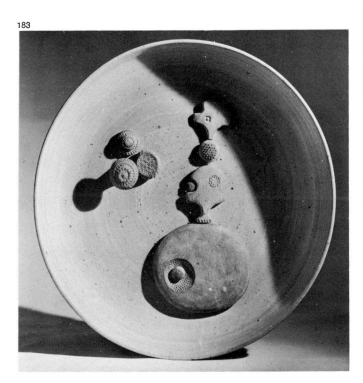

185. Stoneware slab figures by Bengt
Berglund for Gustavsberg of Sweden.
(Courtesy of Svenska Slojdforeningen.)

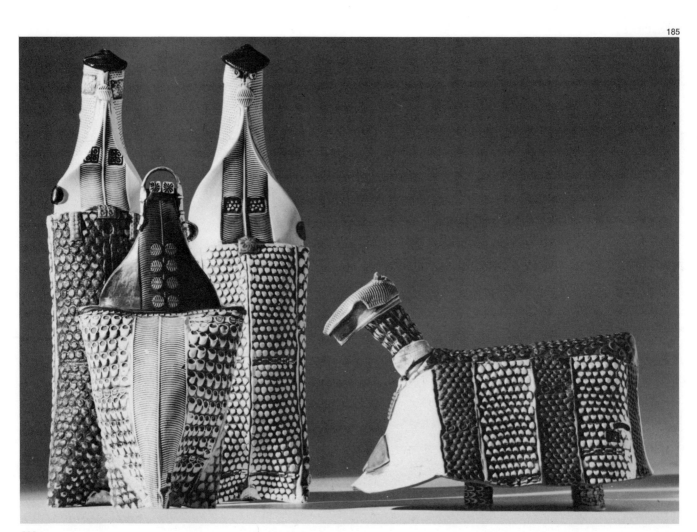

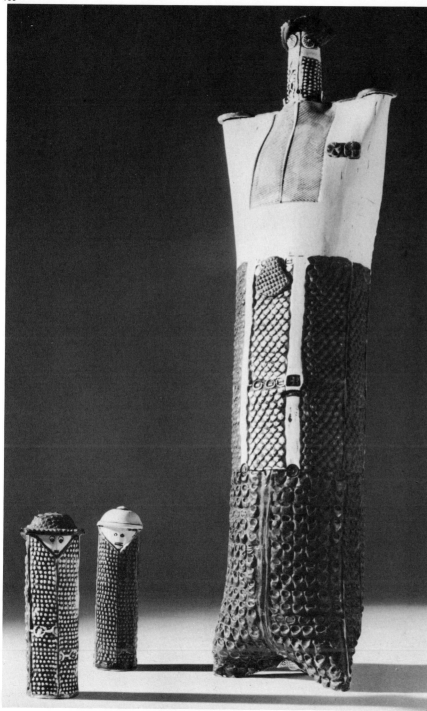

186. Slab-built stoneware figures by Bengt
Berglund for Gustavsberg of Sweden.
(Courtesy of Svenska Slojdforeningen.)

187. "The Choir" by Inger Persson for A. B.
Rorstrand. The form is made from stoneware
chamotte and was fired at 1400°C.

188. Relief in stoneware by Stig Lindberg for
Gustavsberg of Sweden.

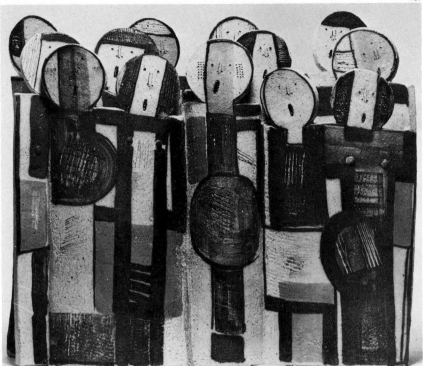

188

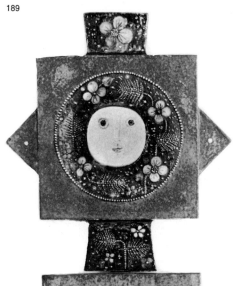

189. Stoneware chamotte relief by Sylvia Leuchovius for A. B. Rorstrand.

190. Stoneware relief by Bente Hansen for Bing & Grondahl. (Courtesy of the Danish Society of Arts, Crafts, and Industrial Design.)

190

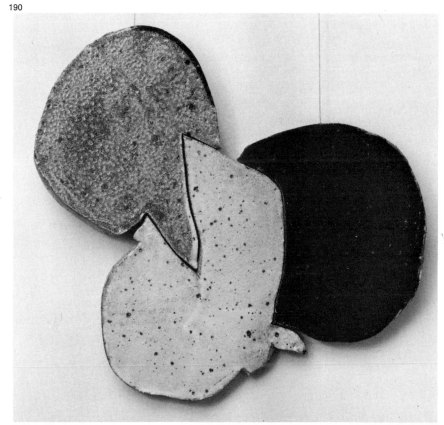

191. Sand-cast free form by Anders Liljefors of Sweden. Piece was fired at 1340°C. (Courtesy of Kollegiet for Sverige—Information.)

192. "Negresses" in porcelain, 64 centimeters high and fired at 1380°C. By Friedl Kjellberg for Wartsila Arabia of Finland.

193. Faïence sculpture with painted polymer surface. By Myron Brody. (Courtesy of Wartsila Ab Arabia. Finland.)

191
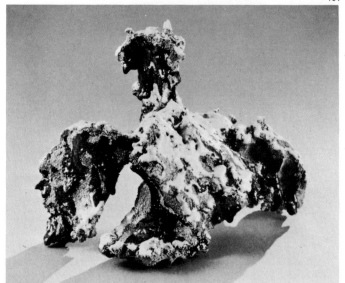

192
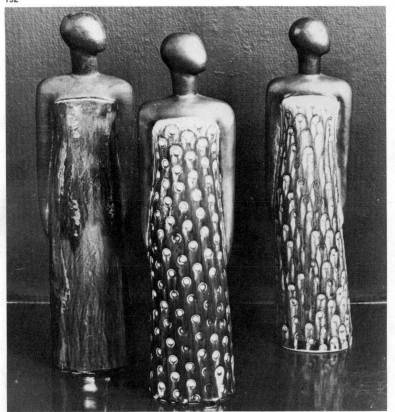

193
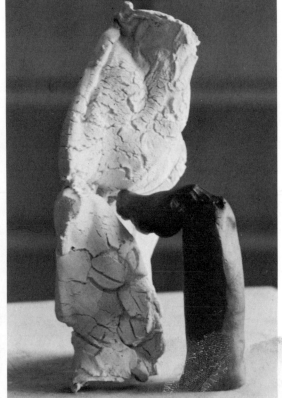

194

195. "Birds," stoneware-chamotte forms by Francesca Lindh for Wartsila Ab Arabia, Finland. Forms were thrown, modeled, and engraved. They were fired at 1375°C.

196. Wall relief in stoneware chamotte, slab-built and engraved. By Francesca Lindh for Wartsila Ab Arabia, Finland. Piece was fired at 1300°C.

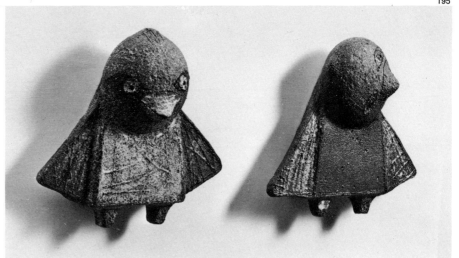

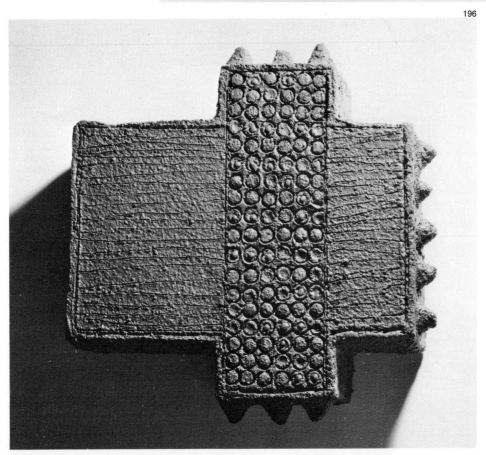

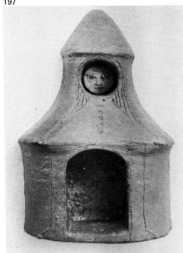

197

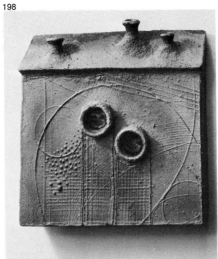

198

197. Stoneware-chamotte wall relief, wheel-thrown and engraved, by Francesca Lindh for Wartsila Ab Arabia, Finland.

198. "House," wall relief in stoneware chamotte by Francesca Lindh for Wartsila Ab Arabia, Finland. Piece was fired at 1375°C.

199. "Faces," stoneware relief by Eija Karivirta of Finland.

199

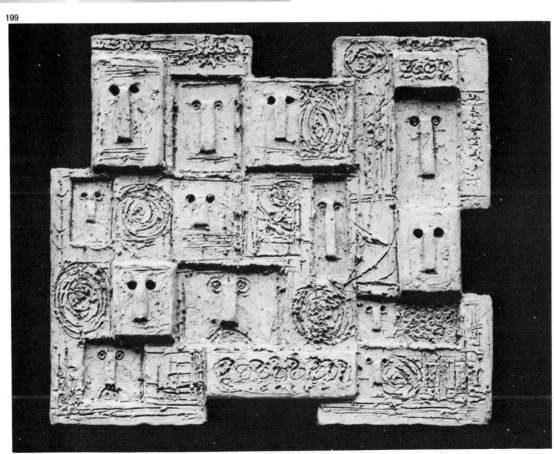

200. Engraved relief by Bjorn Wiinblad of Denmark. (Courtesy of Den Permanente.)

201. Stoneware relief by Arne L. Hansen of Denmark. (Courtesy of the Danish Society of Arts, Crafts, and Industrial Design.)

202. Relief tiles with engraved and applied surfaces by Lizzie Schnakenburg of Denmark. (Courtesy of Den Permanente.)

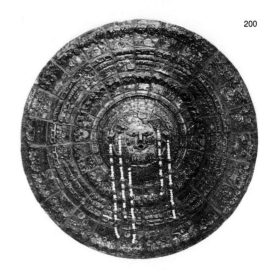

200

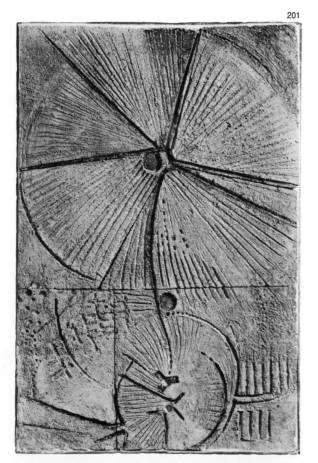

201

202

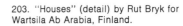

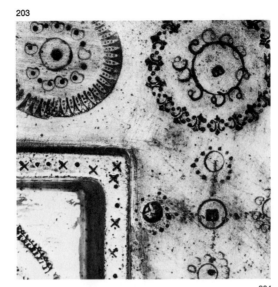

203

203. "Houses" (detail) by Rut Bryk for Wartsila Ab Arabia, Finland.

204. "Town," tile composition, cast and engraved, by Rut Bryk for Wartsila Ab Arabia, Finland. Fired at 1065°C.

205. "Houses" (detail) by Rut Bryk for Wartsila Ab Arabia, Finland.

204

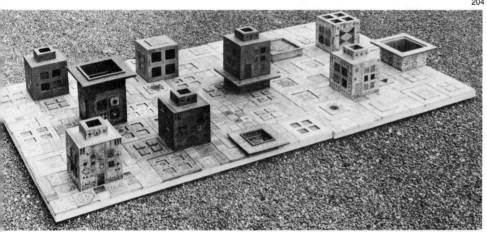

205

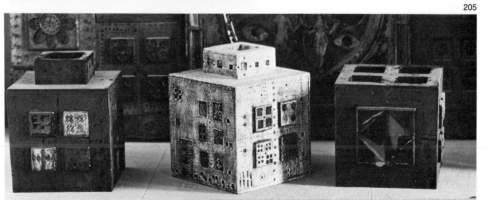

206. Relief bricks used in a wall. By Erik Hoglund of Sweden for Boda Bruks Aktiebolag.

207. Ceramic relief tiles by Birgitta Steffan of Sweden. (Courtesy of Konstindustriskolan, Goteborg.)

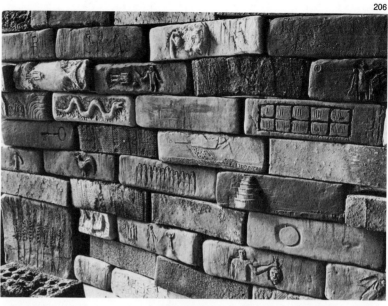

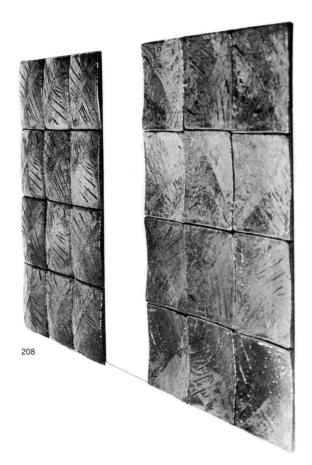

208

209

208. Stoneware wall tiles by Orjan Johansson of Sweden. (Courtesy of Konstindustriskolan, Goteborg.)

209. Cast porcelain tiles for a room divider, decorated with transfer patterns. By Rut Bryk for Wartsila Ab Arabia, Finland.

210. Stoneware relief tiles by Gertrud Kudielka of Denmark for L. Hjorth. (Courtesy of the Danish Society of Arts, Crafts, and Industrial Design.)

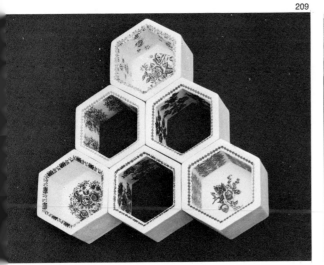

210

ACKNOWLEDGMENTS

In addition to the many potters who contributed to this book, I would like to thank the following organizations and individuals who made my research in Scandinavia possible: Maire Walden and the Finnish Press Bureau; Erkki Savolainen and *Look at Finland* magazine; Sinikka Salokorpi and *Avotakka* magazine; the Finnish Design Center; the Finnish Society of Crafts and Design; Ornamo; and Eila Nevenranta, Kaj Franck, Matti Timola, Olli Alho, and Catharina Kajander—all of Finland. Norsk Design Centrum; *Bonytt* magazine; Landsforbundet Norsk Brukskunst; and Dr. and Mrs. Peter Anker—all of Norway. Svenska Slojdforeningen; the Swedish Institute; Anna-Greta Erkner Annerfalk and Kollegiet for Sverige—Information; Claes-Hokan Wihl, his wife, and Mr. and Mrs. Lennard Petersen; *Sweden Now* magazine; Konstindustriskolan, Goteborg; *Forum* magazine and the Form Design Center in Malmo—all of Sweden. The Danish Society of Arts, Crafts, and Industrial Design; Den Permanente; the Royal Danish Ministry for Foreign Affairs Press Office; *Mobilia* magazine; and Ove Hector Nielsen, Birgit Rastrup-Larsen, Inge Kraus, John Allpass, James Manning, Sandy Willcox, and Mr. and Mrs. Kaj Larsen—all of Denmark.

For travel arrangements, I would like to thank: the Finnish Travel Association; Finnair; Oy Finnlines Ab; the Finnish Steamship Company; Bore Lines Ab; the Foreign Ministry of Norway; the Norwegian State Railway; Scandinavian Airlines System; the Swedish State Railway; Swedish American Line; the Danish State Railway; the Royal Danish Ministry for Foreign Affairs; and the United Steamship Company of Denmark.

I would like to thank the following photographers and agencies who have work included in this volume: Wartsila Ab Arabia; Otso Pietinen; Myron Brody; Jorma Blomqvist; Matti Saves; Ilmari Kostiainen; A. Fethulla; Seppo Hilpo; Kristian Runeberg; and Studio Ulla Finnila—all of Finland. Finn Hald; *Bonytt* magazine; and Bjorn Winsness—all of Norway. Karl-Erik Granath; Volvo Ab; Reijo Ruster; Bengt-Goran Carlsson; Hilding Ohlson; Ulf Sjostedt; Beata Bergstrom; Konstindustriskolan, Goteborg; Stig T. Karlsson; Rune Hassner; Carl A. Nordin; Berndt Klyvare; and Wahlberg—all of Sweden. Ove Hector Nielsen; B. Ilsted Bech; Jan Friis Nielsen; Rigmore Mydtskov; Steen Rønne; K. Helmer Petersen; Ole Woldbye; Nordisk Pressfoto; Carl Rasmussen; Bloch-Baeth; Christopher Hauch; Jesper Hom; Erik Hansen; Struwing; Roald Pay/Delta; Willy Hansen; Mathias; and Gutenberghus—all of Denmark.

MATERIALS FOR FURTHER STUDY

The following books and periodicals may be ordered directly from their publishers in Europe and the United States:

Avotakka (periodical), Hitsaajankatu 10, Helsinki 81, Finland.
Ceramics and Glass, Wartsila Ab Arabia, Helsinki, Finland.
Designed in Finland, Finnish Foreign Trade Association, Et Esplanadikatu 18, Helsinki 13, Finland.
Look At Finland, Finnish Foreign Travel Association, Mikonkatu 13-A, Helsinki, Finland.

Bonytt (periodical), Bygdoy Alle 9, Oslo 2, Norway.

Forum (periodical), Box 7047, Stockholm 7, Sweden.
Sweden Now (periodical), Warfvinges Vag 26, Stockholm, Sweden.

Dansk Kunsthaandvaerk (periodical), Bredgade 58, 1260 Copenhagen K, Denmark.
Handarbejdets Fremme, Vimmelskaftet 38, Copenhagen K, Denmark.
Mobilia, Snekkersten, Denmark.

American Artist, 165 W. 46 St., New York, N.Y. 10036.
American Ceramics Bulletin, 437 Fifth Ave., New York, N.Y.
The American Scandinavian Review, 127 E. 73 St., New York, N.Y. 10021.

Art in America, 635 Madison Ave., New York, N.Y.
Ceramics Monthly, 4175 North High St., Columbus, Ohio 43214.
Craft Horizons, 44 W. 53 St., New York, N.Y. 10019.

The following Scandinavian schools offer courses in ceramics:

Ateneum, Railway Square, Helsinki 10, Finland.

Statens Handverks og Kunstindustri-skole, Ullevalsvejen 5, Oslo 1, Norway.
Statens Kunstindustriskole, Bergen, Norway.

Konstfackskolan, Valhallavegen 191, Stockholm, Sweden.
Konstindustriskolan, Kristinelundsgatan 6-8, Goteborg C, Sweden.

Kunsthaandvaerkskolen, Copenhagen, Denmark.
The Royal Danish Academy, Kongens Nytorv 1, Copenhagen, Denmark.

Scandinavian design and handicraft societies and exhibitions:

The Finnish Society of Crafts and Design, Unioninkatu 30, Helsinki 10, Finland.

Landsforbundet Norsk Brukskunst, Uranienborgvejen 2, Oslo, Norway.

Svenska Slojdforeningen, Nybrogatan 7, Box 7047, Stockholm 7, Sweden.

The Danish Society of Arts, Crafts, and Industrial Design, Bredgade 58, 1260 Copenhagen K, Denmark.